Marc Chagall

Great Modern Masters

Chagall

General Editor: José María Faerna

Translated from the Spanish by Elsa Haas

CAMEO/ABRAMS

HARRY N. ABRAMS, INC., PUBLISHERS

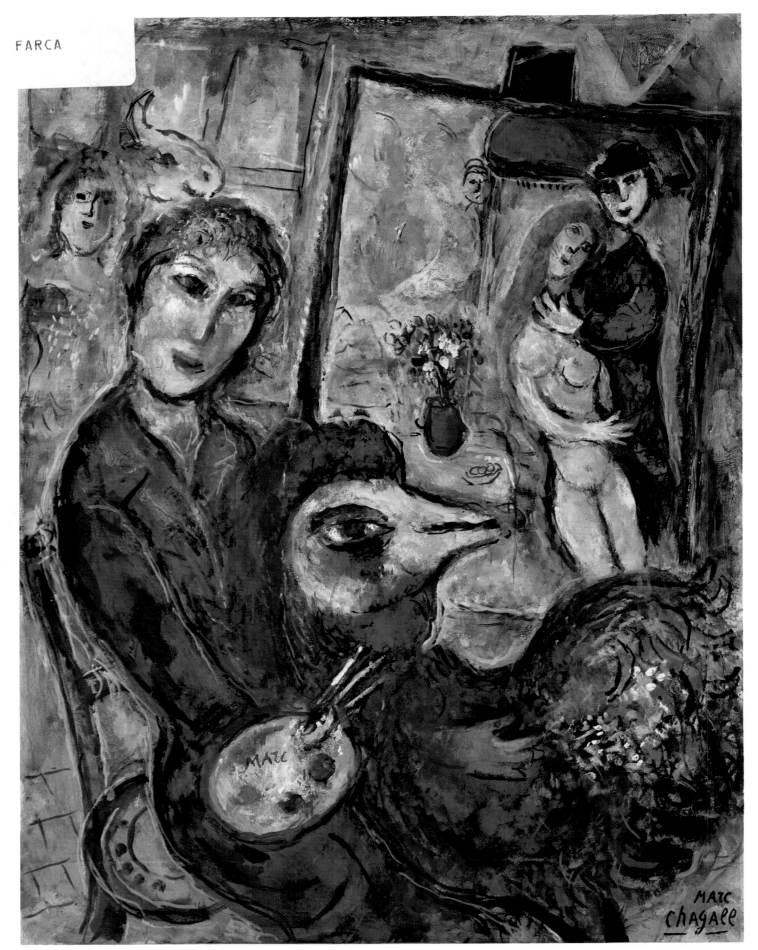

The Studio, *1959–68. Oil on paper reinforced with canvas, 25⅝ × 19¼ (65 × 49 cm). Private collection.*

Marc Chagall

Chagall's Bohemian companions in Paris called him "le poète"—the poet—and in certain respects this nickname, with all its implications, defines how the artist was later to be viewed by critics and historians of art. Indeed, Chagall's identity as a painter-poet led André Breton to characterize him as the great genius of the plastic arts with whom "metamorphosis made its triumphal entry into modern painting." The artist's love of literature, religious symbols, and folk tales, and his embrace of these themes in his art, was scorned by the most radical of the avant-garde, who rejected traditional subject matter along with so much else. However, neither of these two characterizations—poetic spirit or literary interpreter—suggests the full significance of Chagall's work, which is prolific, versatile, and partially rooted in cultural traditions foreign to the tradition of Western art.

Chagall experimented with a wide range of techniques, including stained glass.

The Metamorphosis of the Arts

Chagall, the lyric poet of the artistic avant-garde, was a painter of music, in its most abstract and inaccessible sense. He was also a great designer, a wizard of theatrical scenography, a painter of the walls and ceilings of those great temples of Western culture, opera houses, auditoriums, and museums. He gave new life to the arts of mosaic and stained glass. Whether as painter-poet, painter-musician, painter-designer, painter-scenographer, Chagall always sought to integrate the artistic disciplines. Above all, he was a painter of "metamorphosis," of the genres, of color, and of form, transforming and overlapping the arts, as so many of the avant-garde advocated.

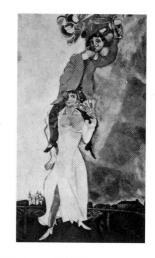

Double Portrait with Wine Glass, *1917–18. Chagall's art always explored his private world; here he is shown with his first wife, Bella.*

The Musician, *1922. Music is a constantly recurring motif in Chagall's work.*

Transmutations

The Surrealists, to whom Chagall was always close, although he was never, strictly speaking, one of them, embraced metamorphosis as one of their fundamental motifs. For them, reality was a continuum of images and experiences, of boundaryless flux and elision. From his first contacts with the Parisian avant-garde, Chagall fully assumed this metamorphic view of the world. He first assimilated the chromatic liberation of the Fauvists, who rejected any adherence to realism in color or dependence on the verisimilitude of the subject. In the Fauve vision a face could be green, a cow red or blue. Perhaps more radically, colors could cross the borders of objects and establish autonomous relationships with them and each other. Chagall also assimilated the revolutionary Cubist destruction of three-dimensional space and its visual reconstruction in the realm of time and memory. As a result, Chagall's figures inhabit spaces of transmutation, in which references to the past and the present meet, and the relationships between the sky and the earth, or the foreground and the

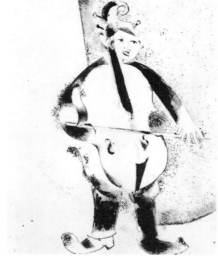

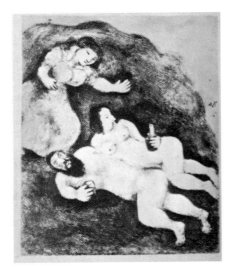

Lot and His Daughters, *1936–39. One of the artist's illustrations for the Bible, commissioned by Ambroise Vollard.*

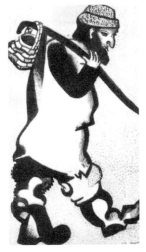

The Jew with the Cane, *1913. Chagall's background in the Jewish community of Eastern Europe was always reflected in his work.*

The Mermaid of the "Baie des Anges," *1962. The light and color of the Mediterranean pervade the artist's later works.*

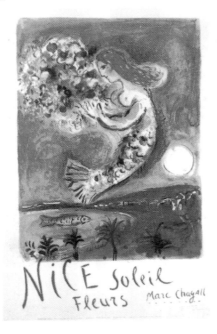

background, are often inverted. The horizontality of his landscapes and the verticality of his standing human figures are thus not the ruling principles of his spatial logic. In his art figures are superimposed and soar through the air, heads are separated from trunks, limbs divide, and drapery breaks into facets.

Cultural Roots

But, no matter how great Chagall's interest in and love of tradition, he was always much more than a transmitter, or even an interpreter, of previous experience and cultural memory. Furthermore, his assimilation of the innovations of the avant-garde was completely personal. From his first encounter with the avant-garde in Paris, he clearly rejected its analytic approach, and the experimental and "scientific" frame of mind that hoped to wipe the cultural slate clean and start from zero. The problems he had as Director of the Vitebsk School of Art with Malevich and Lissitzky are ample proof of this. Over and over, Chagall reaffirmed the symbolistic traditions of his native country. He was intent on projecting the artistic liberation of the avant-garde on the great myths of his people, on reinterpreting the traditions of the Jewish culture of Eastern Europe in a universal visual language. He eagerly embraced the stories of the Bible, but with a sensibility tempered by a traditional aversion to idolatry. "When I paint the wings of an angel, these are also flames, thoughts, or desires. . . . The worship of the image itself must be done away with. . . . Judge me by shape and color, by a vision of the world, not by individual symbols. . . . A symbol must not be a starting point, but an endpoint."

Reinterpreting reality as a series of mutations clearly affected Chagall's form and subject, and, not surprisingly, it also affected his relationship with his past and his own cultural and artistic traditions. Shortly after the beginning of the Russian Revolution, Chagall said, "The proletarian painter knows perfectly well that he and his talent belong to society." Although he later left Russia and the enormous changes taking place there, he never repudiated this statement. Chagall's rejection of the formalistic self-absorption of the radical avant-garde and his reaffirmation of his cultural origins and religious background were not an evasion, or a retreat into "mysticism," as has been charged, but an embrace of the world around him.

Art, Love, and Celebration

For Chagall, this embrace of the world manifested itself on several levels. First of all, it was present physically, in his hands-on interaction with his materials, through his use of thick impasto, his continual experimentation with new media, and his creation of imposing decorative schemes. Secondly, it was personal, in his constant references to love, in his images of women, of animals, and of people he cared for, as a source of universal transforming energy. And lastly, it was communal, in his exaltation of shared celebrations: the circus, the theater, and communal prayer. This intense feeling for involvement in the world around him, though not always well understood, has made Chagall one of the most popular figures in twentieth-century art.

Marc Chagall / 1887–1985

Marc Chagall was born in the Jewish ghetto of the Belorussian city of Vitebsk, into a large but poor family, the oldest of nine brothers. His father worked in a salted herring plant while his mother managed the household. Even in his schooldays, the boy showed a clear inclination toward drawing. Going against the Jewish prohibition of the creation of images, at the age of nineteen he began to work in the atelier of a local painter, Yejuda Pen; he also worked as a retoucher in a photographic studio. Two years later, Chagall moved to Saint Petersburg, where he lived from hand to mouth for some time as he looked for a way to earn a living with his art. After spending a short period as a student of the School of Fine Arts, he was introduced to Leon Bakst, the renowned designer of sets and costumes at the Russian Ballet, who became his teacher. Bakst was soon to realize the creative independence of the young painter, commenting, "After listening intently to my lesson, he takes his pastel pencils and does things that completely differ from what I do."

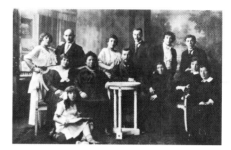

The artist's family in Vitebsk. Chagall is second from the right.

The Parisian Avant-Garde

In 1910, a patron sponsored Chagall's move to Paris. The next year, Chagall moved into a studio in "La Ruche" (The Beehive), an artist's group settlement in the Vaugirard district, where he was to maintain a studio until he left Paris in 1914. There he struck up a friendship with some of the Parisian avant-garde, especially the poets Blaise Cendrars and Guillaume Apollinaire, and the painters Chaim Soutine, Fernand Léger, and Robert Delaunay. The influence of this new milieu was immediately observable in his work. As early as 1911, compositions such as *I and the Village* and *The Poet*, among others, reveal a new distance from the naïve realism of his previous works, and the assimilation of both Fauvian colorism and the Cubist and Orphic spatial innovations. However, despite this plunge into formal and coloristic experiment, Chagall only infrequently left his personal iconographic universe. This world was populated by childhood memories—the landscape of Belorussia, scenes of peasant life, and Jewish celebrations. There were also constant references to people he loved, especially Bella Rosenfeld, a young woman from Vitebsk whom he would marry in 1915.

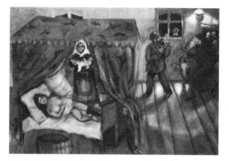

The Birth, *1910. Before arriving in Paris, Chagall worked in a "naïve" representational style.*

Return to Vitebsk

This peculiar avant-garde interpretation of his cultural roots was to be put forth in various exhibitions in Paris and Berlin until 1914, the year in which Chagall returned to Vitebsk. What he expected would be a short visit turned into a period of eight years spent in the three cities of Vitebsk, Petrograd, and Moscow because of the outbreak of the World War I and the ensuing revolution. During these years, Chagall developed an even more personal approach to his work and moderated his avant-garde experiments. Although in principle he sympathized with the revolution

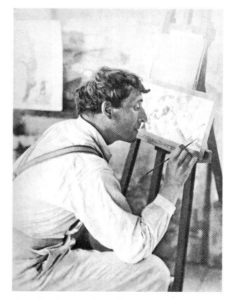

The artist at work on the preparatory sketch for Introduction to the Jewish Art Theater, *1920.*

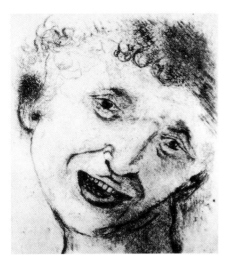

Self-Portrait, Smiling, *1924–25.*

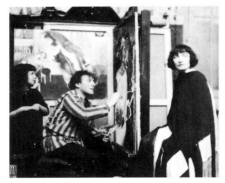

Chagall, with his first wife, Bella, and their daughter, Ida, in his studio in Paris, 1927.

Chagall and his second wife, Valentine Brodsky. Valentine was an important source of inspiration in the latter part of his artistic life.

and his name was put forth for the post of director of the plastic arts department at the Ministry of Culture in Moscow, he preferred to settle down in Vitebsk and work as the Commissar of Fine Arts and the director of the local art school. However, conflicts with the other members of the faculty, especially Malevich and Lissitzky, who were radically opposed to Chagall's "traditionalism," soon emerged. In 1920 Chagall left his post and moved to Moscow, where he worked as a scenographer and drawing instructor in camps for orphaned children.

Lights and Shadows

In 1922, Chagall definitively left Russia and moved to Berlin. A year later he returned to Paris. Then came a fruitful professional period marked by his contacts both with the merchant Ambroise Vollard, for whom he illustrated several books, including one edition of the Bible, and with members of the Surrealist movement. During this time he also participated in numerous exhibitions and traveled continually, through France and to other countries including Egypt, Palestine, Holland, Italy, and Poland. In 1934–35 he traveled in Spain, where the work of El Greco deeply impressed him. The publication of the artist's autobiography, *My Life*, in 1931, and a retrospective exhibition of his work at the Museum of Basel in 1933 guaranteed his elevation to the European artistic canon. However, historical events cut this progression of good fortune short. Nazi persecution and the War drove him into exile in the United States in 1941, and the move signaled important changes in his work. These changes were reinforced by the tragic death of Bella in 1944, after which the painter was unable to work for nearly a year. When he finally could bring himself to paint again, his former palette of bright colors had shifted to dark tones and gloomy effects. In most of the works of the mid-1940s, his colorful, poetic dreams seem to have turned into nightmares.

Fame

In 1948, Chagall returned to France, and two years later moved to Saint-Paul-de-Vence, where he was to live the rest of his life. Beginning in 1946, a series of important retrospective exhibitions in European and American cities—New York, London, Paris, Amsterdam, Zurich, Bern—made his work known to the larger public and established his permanent international reputation. After he returned to France he met Valentine ("Vava") Brodsky, who was to play an important role in Chagall's recovery as a painter. They were married in 1952. Thanks to her support, Chagall was able to undertake ambitious projects with large institutions. Among the more important of these was the cycle of paintings *Biblical Message*, which he finished in 1966 and which was installed in 1973 in the Museum of the Marc Chagall Biblical Message in Nice; the ceiling of the Paris Opéra, which he decorated in 1964 at the request of Charles De Gaulle and André Malraux; and the great murals for the Metropolitan Opera House in New York. During this period, with the help of such master craftsmen as the lithographer Charles Sorlier and the glazier Charles Marq, he also experimented with a wide variety of techniques and media. In the last years of his life he was continually paid homage.

Plates

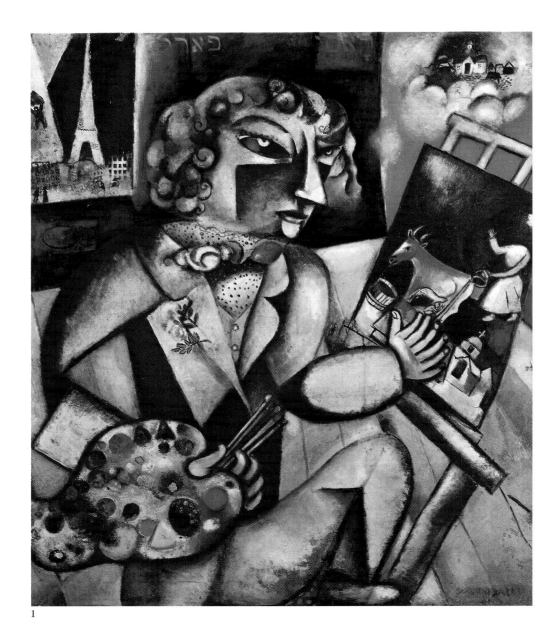

1

The Avant-garde and Tradition

Before he arrived in Paris, Chagall's style was realistic, relatively naïve, and lacking in all but historical interest. His first significant works, dating to 1910, are the fruit of his rapid assimilation of the pictorial experiments of the Parisian avant-garde, whose essential points of reference were the last stages of Fauvism, the omnipresent style of Cubism, and the Orphism of Robert Delaunay. To all of this must be added the profound influence of the literary work of Chagall's friend Blaise Cendrars, who conceived his novels and poems as evocative repertories of juxtaposed images. Chagall's leap into the avant-garde arena did not, however, lead to any rupture with his past. He was to say later, "Even as I was in France undergoing a process of deep transformation of artistic technique, I returned to my country in my memory, with what might be called my soul." This reconciliation between the avant-garde and the traditional, between the present and the past, is a constant feature of all Chagall's works.

1 Self-Portrait with Seven Fingers, *1912–13. Here Chagall portrays himself in his studio, working on a painting evocative of his first years in Paris,* To Russia, To the Asses, and To the Others *(illustration 5). The avant-garde artist is shown painting an image of life in Russia with a seven-fingered hand.*

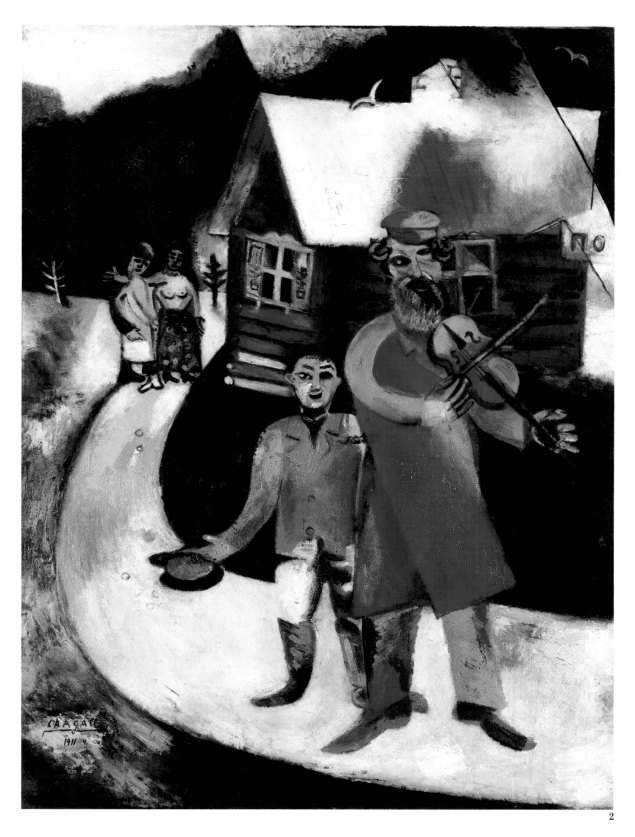

2

2 The Violinist, *1911. The influence of Fauvism is strongly
evident in this painting. Here Chagall has transformed a folk
image from his childhood—the violinist whose playing
accompanies all important Russian Jewish celebrations—into an
explosion of intense colors in the night.*

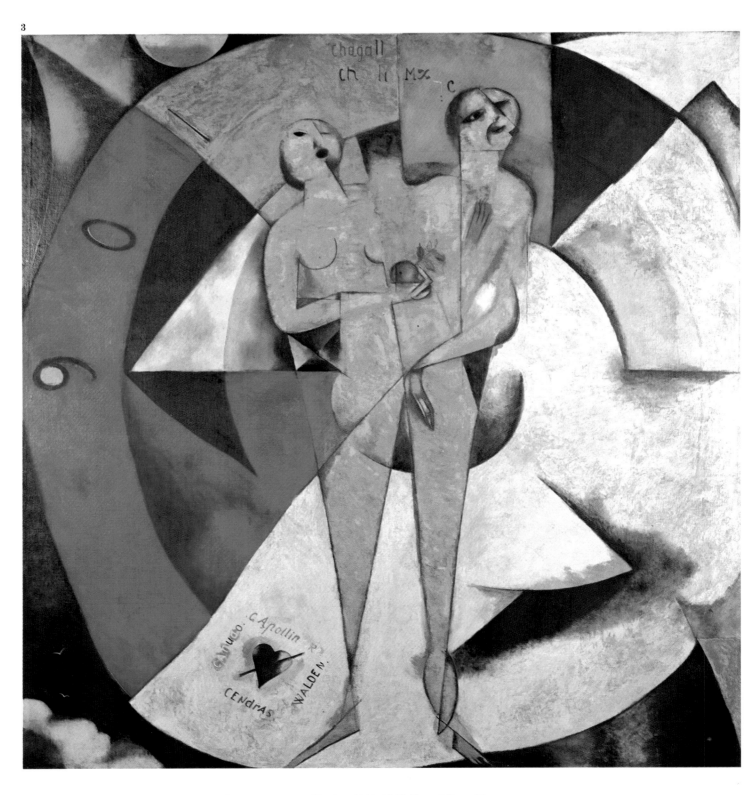

3 Homage to Apollinaire, *1911–1912. One of Chagall's most cryptic compositions, an avant-garde representation of the Biblical theme of Adam and Eve. The chromatic dynamism of the spiral in the middle distance—a metaphor for the passage of time—reveals the influence of the Orphic experiments of Delaunay. Chagall dedicated the painting to Apollinaire after the poet visited his studio in 1913; in 1914, however, he reaffirmed his commitment to his intellectual sources by inscribing the name of Apollinaire along with those of Cendrars, Canudo, and Walden in the lower left-hand corner of the work.*

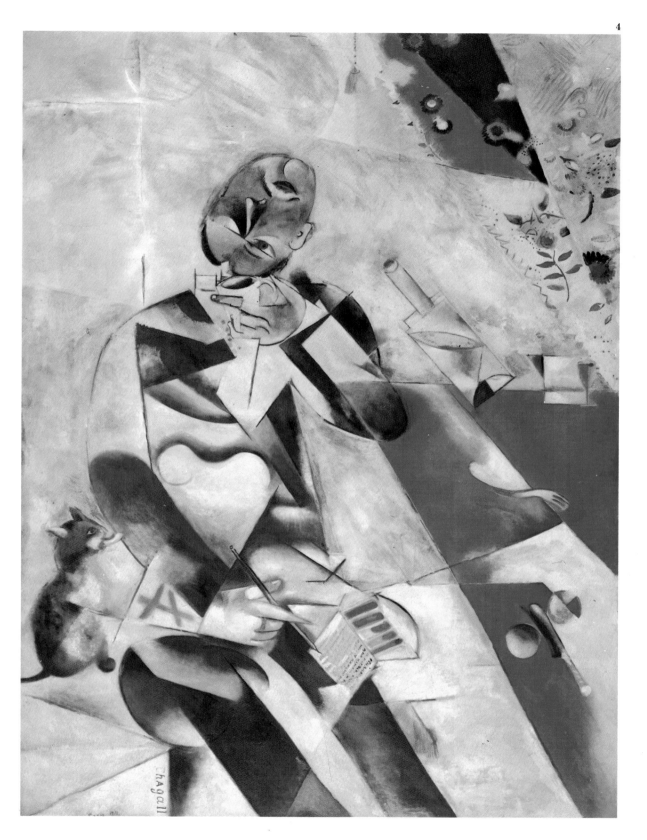

4 The Poet (Half-Past Three), *1911. The formal fragmentation and clarity of this work are clearly reflections of Cubist and Futurist experiments. The poet is shown alone in his room in the early hours of the morning, while the energy of his imagination spills out into the surrounding space, bringing it to life.*

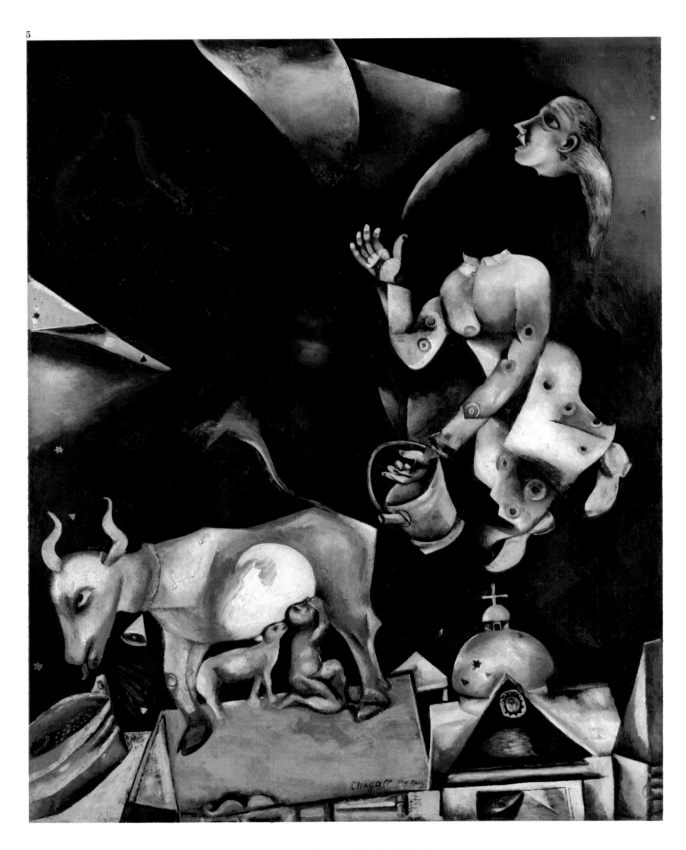

5 To Russia, Asses, and Others, *1911–12. While the preparatory sketch for this work was a simple rural image, in the final version the painting has become a magical panorama of evocative primitive emblems: the cow is now a nurturing image, while the milkmaid frees herself from her work and flies through the night sky. These motifs—maternity, fertility, flying, and the night— were some of the most common symbols in Surrealist imagery. The title of the work was suggested to Chagall by Blaise Cendrars.*

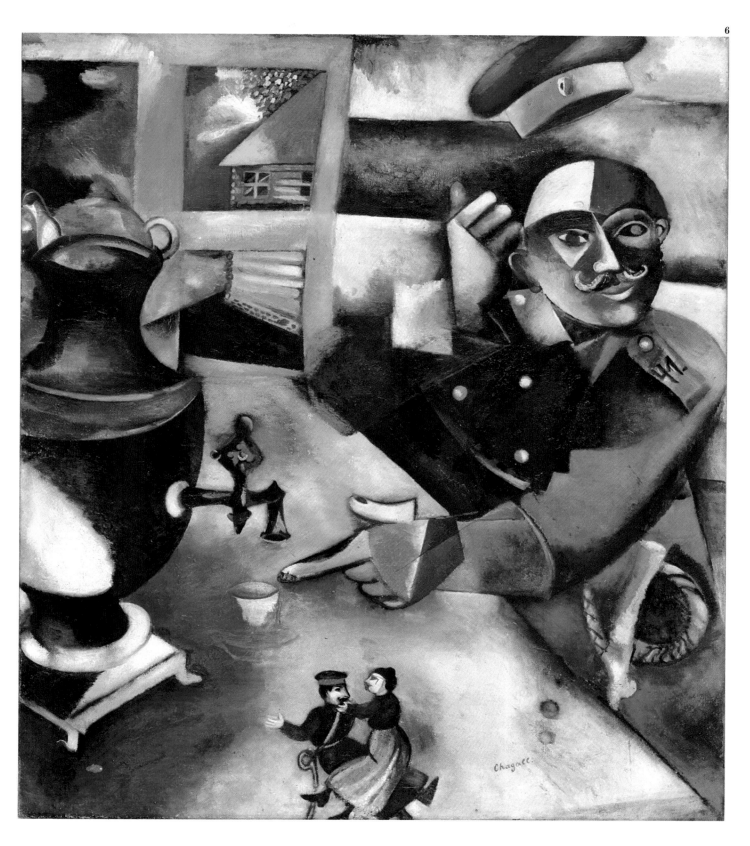

6 The Soldier Drinks, *1912. The intense color of this grotesque image of a soldier in a tavern reflects Chagall's assimilation of the Fauvian and Orphic experiments. Here the colors have their own life, evoking emotional responses from the viewer that do not always correspond with the objects associated with them. The colors as a whole, however, impart an intensity of feeling to the picture appropriate to revelry and drinking sprees.*

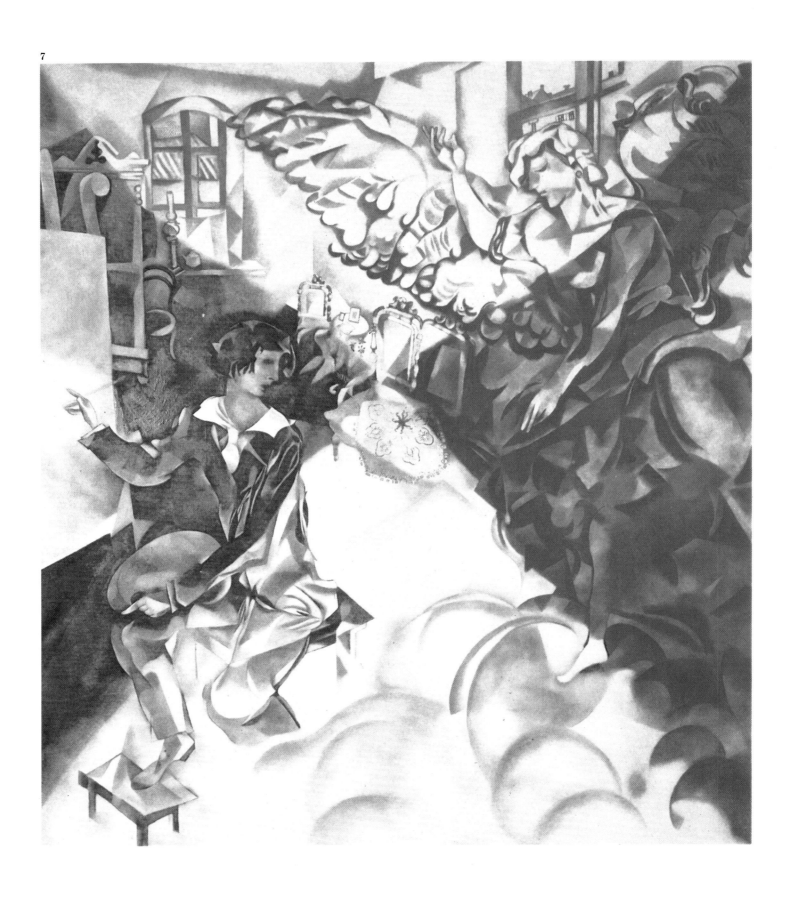

7 The Apparition, *1917. Throughout his life, Chagall reinterpreted religious motifs in the avant-garde vocabulary. The angel in this painting, for example, recalls traditional representations of the Annunciation, acting as a metaphor for the inspiration that the artist receives as he works in his studio. Chagall's debt to the Romantic and symbolist traditions is particularly evident.*

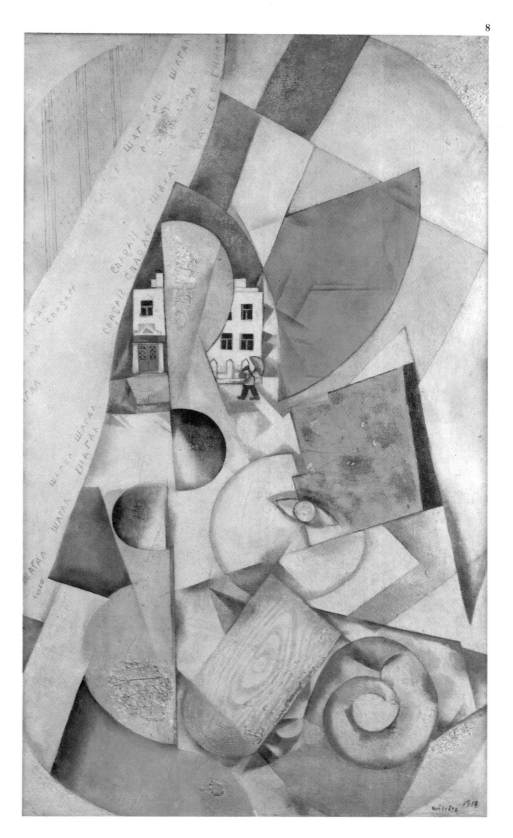

8 Cubist Landscape, *1918. Even in works of clearly Cubist inspiration in which he attained a considerable degree of abstraction—not a common occurrence— Chagall often introduced some figurative motif or reference to his cultural origins. Here, such an allusion can be seen in the insistent repetition of the artist's signature, in both Latin and Cyrillic characters.*

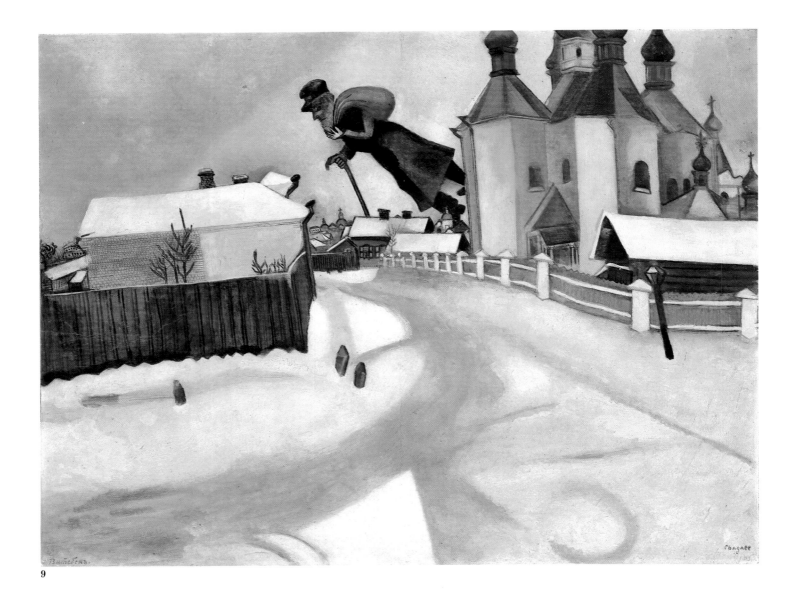

9

Vitebsk

Chagall's return to his native city of Vitebsk in 1914 began a period in which he established his personal style by picking and choosing from the many options offered by the avant-garde. In contrast to the political turbulence Europe was experiencing, Chagall's principal works from this period reflect an intense concentration and are markedly morose in tone. It is as though, amidst so many revolutionary energies and so much war, the painter needed to dig down into his background, into the foundations of his culture and his private world. Two themes recur often in Chagall's paintings of this period. One is that of the rural environment, populated with allusions to Jewish culture—rabbis, fiddlers, the Hebrew alphabet, the star of David. The other is the image of Bella, his wife, the foundation of his happiness. Both motifs were to appear in his work frequently in later years.

9 Over Vitebsk, *1914. The wandering Jew flies over the artist's silent native city, depicted as a lifeless desert of snow. In this period, Vitebsk was to Chagall "a land apart, an odd city, unattractive and boring."*

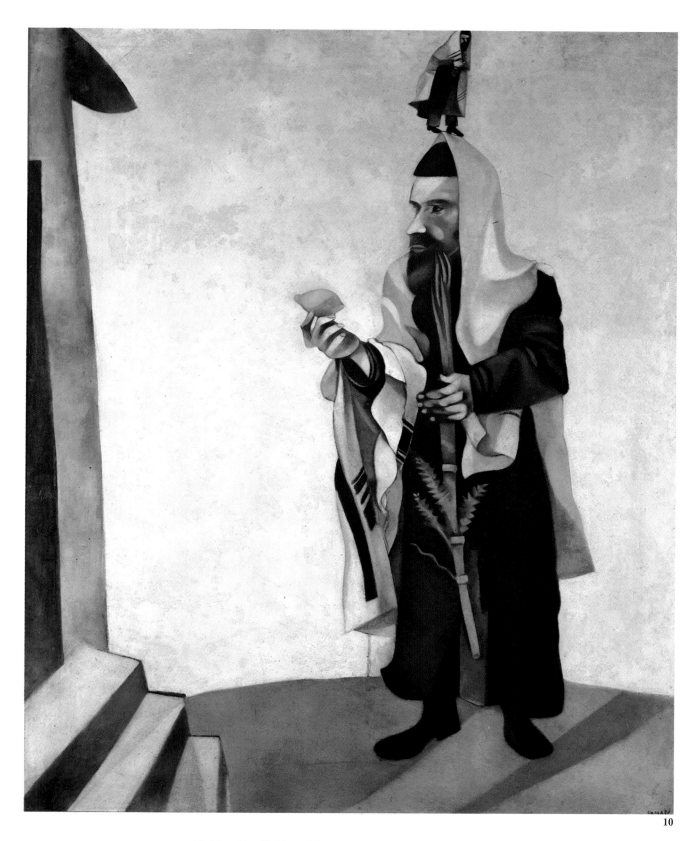

10

10 Feast Day (Rabbi with Lemon), *1914. A somber representation
of a rabbi in the celebration of the Jewish festival of Sukkoth. The
strange placement of another, smaller rabbi on the head of the main
figure may be an allusion to his preoccupation with his faith.*

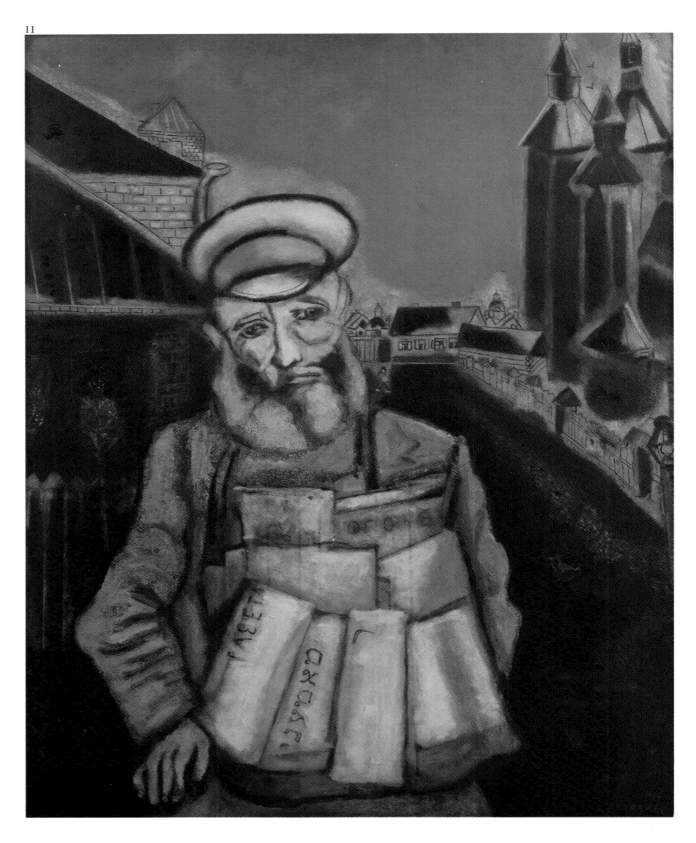

11 The Newspaper Seller, *1914. A poignant image of a newspaper vendor—possibly a metaphor for the wandering Jew— who crosses the dark city under a bloodshot sky. "I had the impression that the old man was green; maybe a shadow from my heart was falling on him," Chagall explained.*

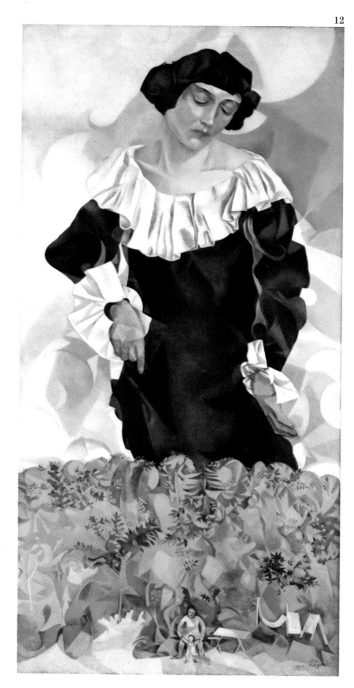

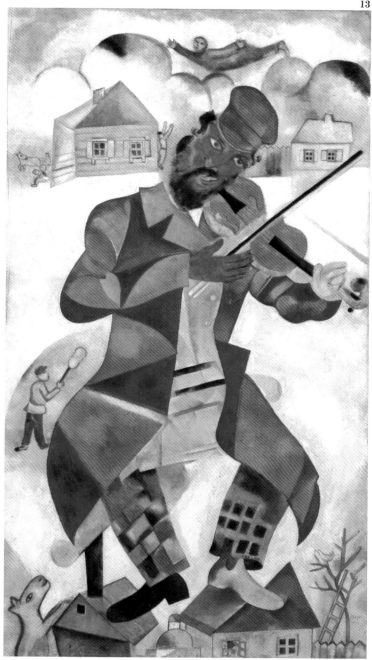

12 Bella with a White Collar, *1917. Only the presence of Bella could bring Chagall to put aside the tone of sadness that pervades most of his work in this period. Bella is the guardian of the happiness of the painter and that of their daughter Ida, who are shown as the minute figures at the lower edge of the composition.*

13 The Violinist in Green, *1918. To Chagall, the violinist is a mythic figure. As an indispensable accompanist to the births, weddings, and burials of the Jewish community, he is a kind of witness to all human existence. Like the painter, he also possesses the cathartic power of art.*

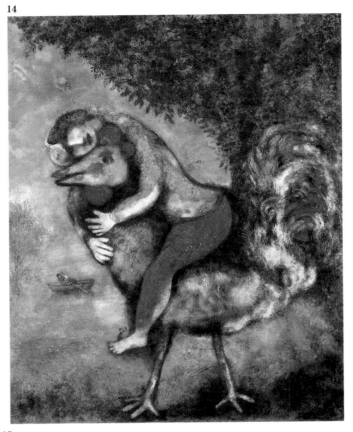

14

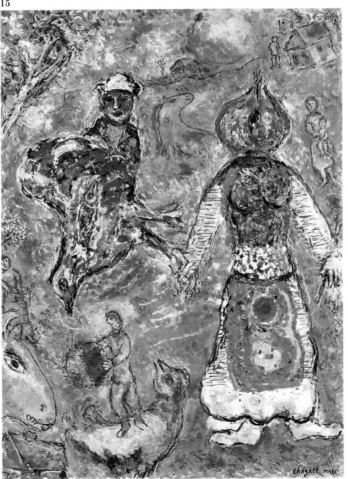

15

Metamorphosis

Chagall's pictorial world is constantly in the process of metamorphosis; it is often impossible to fix the identity of the different motifs appearing in a painting. Although this continual interchange affects all the elements that make up the image—the landscape, objects, living things—it is especially striking in his representations of people and animals. The transformation may involve their characteristics and attributes—a peasant woman may have the head of a bird, a horse may be green or red—as well as their actions—a girl is shown riding a rooster, or a cow flying like a bird. His characters generally are inhabitants of the peasant world, whether people of the rural community or such domestic animals as cows, horses, donkeys, or roosters. The village was a favorite setting for Chagall's play of identity, just as the circus ring was later to be.

14, 16 The Rooster, *1929*. Peasant Life, *1925. Animals are important protagonists in Chagall's paintings. Their relationships to humans are like those that people maintain among themselves, ideally governed by the principle of love.*

15 The Fantastic City, *1968–71. The disturbing presence of two metamorphic images, the bird-woman and the bird-fish, marks this magical scene of striking colors.*

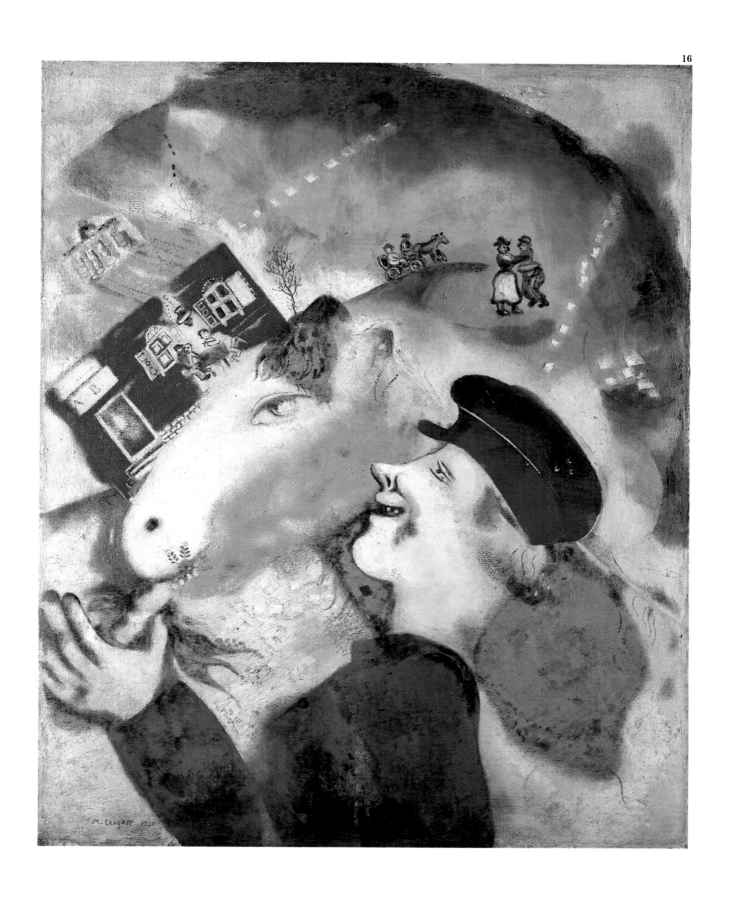

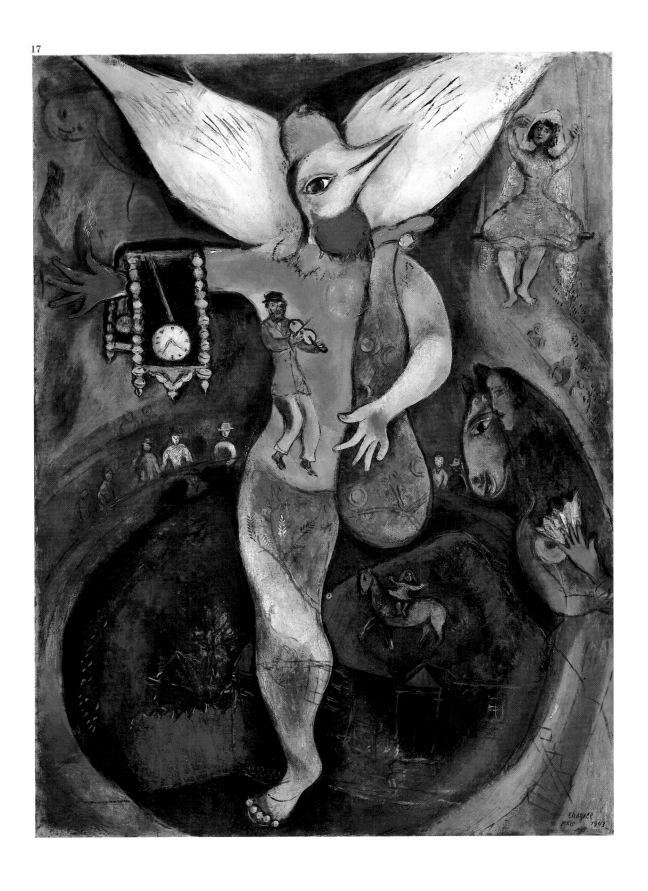

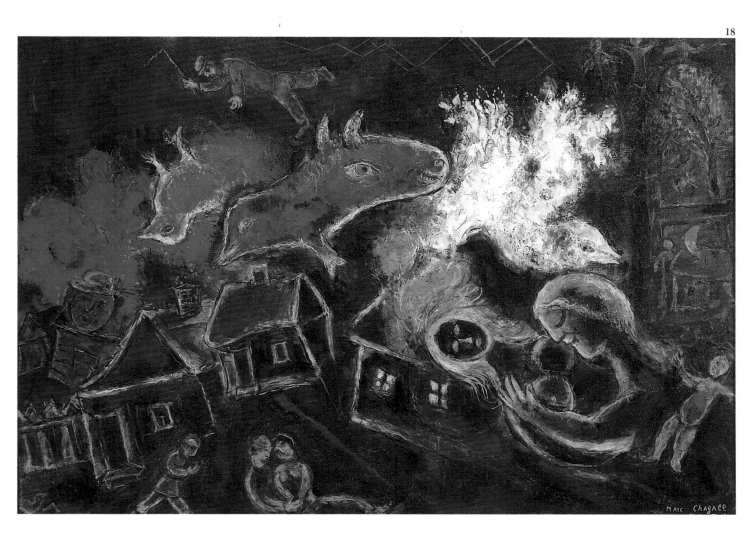

17, 18 The Juggler, *1943.* Birds in the Night, *1967. Birds,*
metamorphically changed and merged with other beings, are the
actors in a performance in one painting, and creatures of the
night in the other. In The Juggler, *the rooster-ballet dancer-angel*
represents the humorous changeability of identities in the circus
ring. In the nocturnal landscape, on the contrary, the birds,
transformed into stars, represent the passionate solitude of lovers.

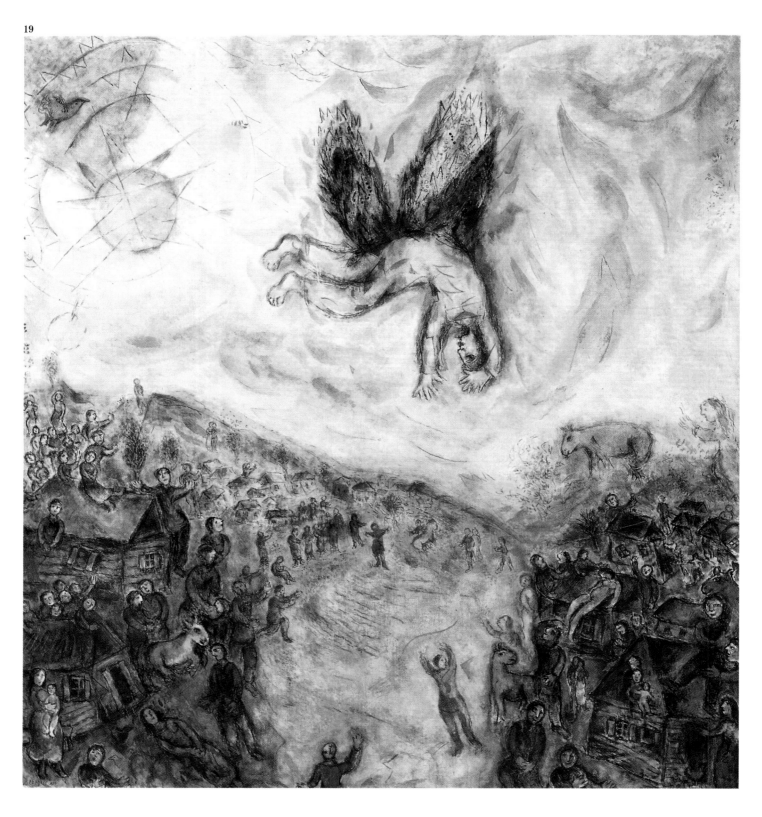

19 The Fall of Icarus, *1975. Chagall reinterprets the Greek myth
of Icarus, who made wings of feathers and wax to escape his
prison in Crete, but paid with his life for the audacity of wanting
to reach the sun. This image of Icarus goes back again to the idea
of metamorphosis, to the tragedy of the man-bird.*

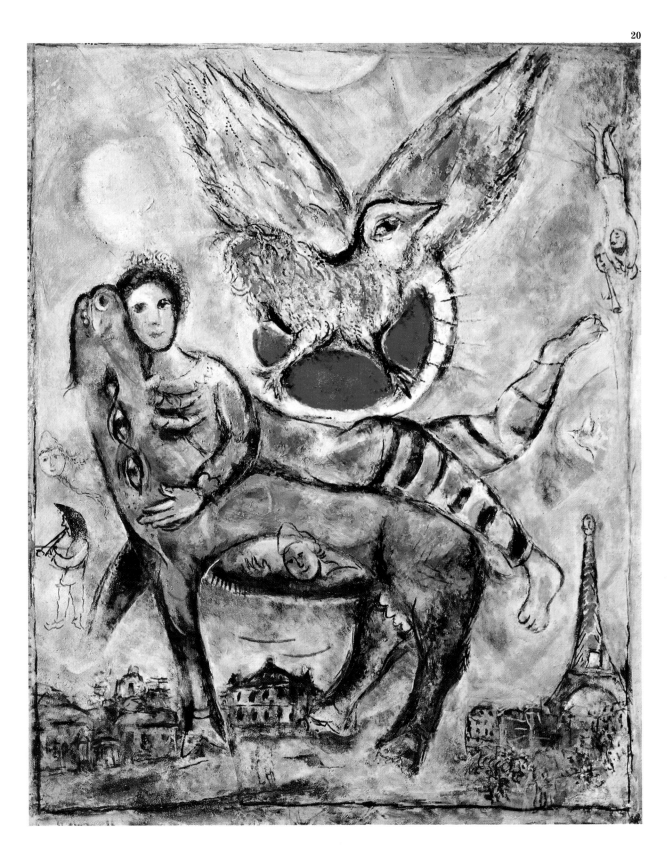

20 The Sun-Bird, *1969. If in the earlier painting the tragedy of
an impossible metamorphosis was reflected, in this one the fusion
of two primitive symbols, the bird and the sun, is exalted. Under
its aegis is spread a scene of other transformations.*

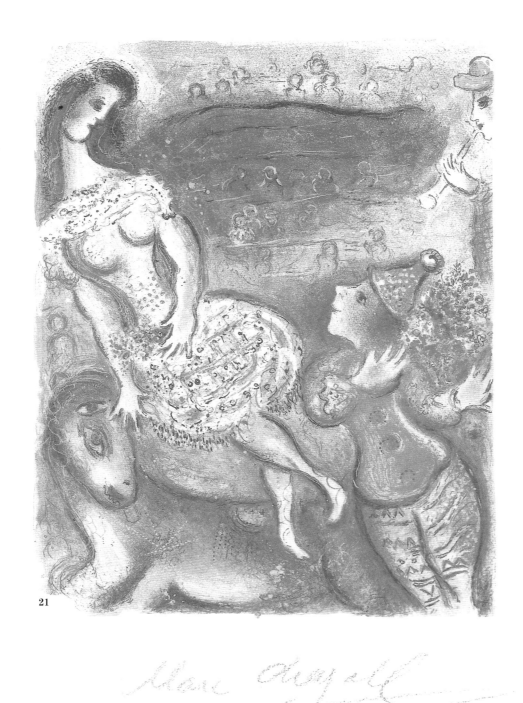

21

The Magic Show

Chagall's interest in celebrations and performances dates back to his first works, to his youthful images of weddings, dances, and other rural festivities. His contact with the world of theater started in 1920, when he collaborated with the Kamerny Jewish Theater of Moscow. Later on he was to design sets and costumes sporadically, and to take charge of the interior decor of places like the Paris Opéra. However, it was not until the 1960s that his fascination with the theater world was to materialize as a mythic image in his paintings: the circus. From then on, the circus ring definitively replaced the landscape of the village as his setting for transformation and magic, becoming the arena where all realities and all phantoms meet. The circus is for Chagall the nexus of gestures, words, color, and music; it is the material manifestation of the modern utopia of the all-embracing work of art.

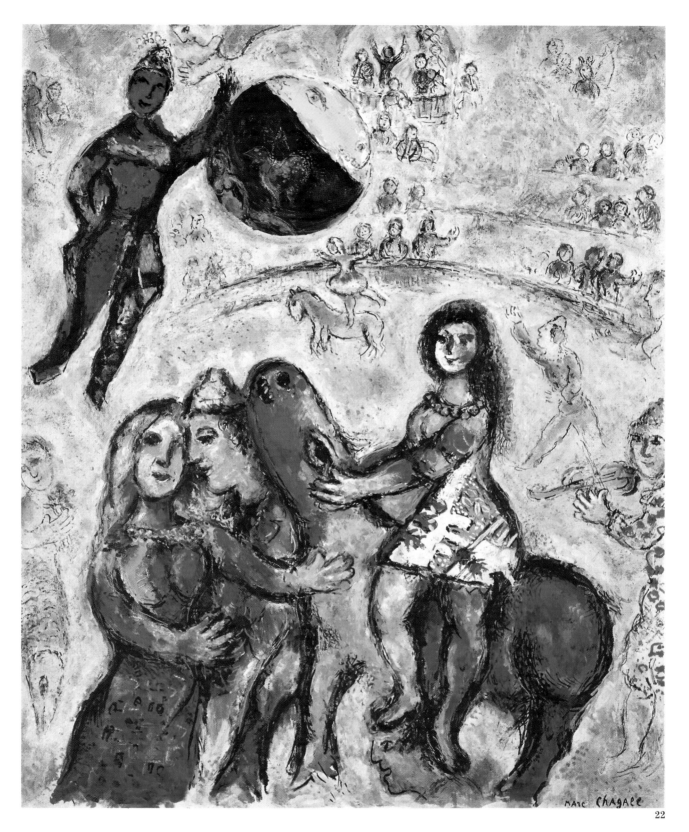

21, 22 Circus Scene. Entering the Ring, *1968–71. Clowns, equestriennes, jugglers, ballet dancers, and musicians are the main characters in the numerous circus scenes Chagall produced beginning in the 1960s.*

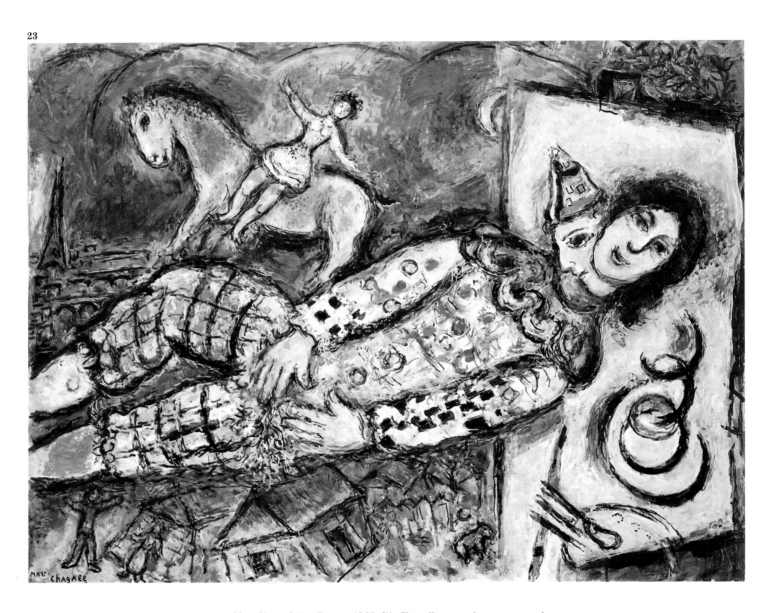

23

23 Clown Lying Down, *1968–71. Chagall many times expressed his identification with the figure of the clown. In this case, the images of the painter and the clown intertwine on the canvas. Around them, as in a dream, appear an equestrienne and the two cities of Paris and Vitebsk.*

24 Carnival at Night, *1979. Beings similar to ones acting in the circus ring meet in this carnival scene. Like the carnival, the night is a suitable setting for transformation, for the dissolution of identities and dreams.*

25 The Great Parade, *1979–80. Another circus scene with its familiar cast of characters: trapeze artists, musicians, equestriennes, clowns, all infused with intensely bright color.*

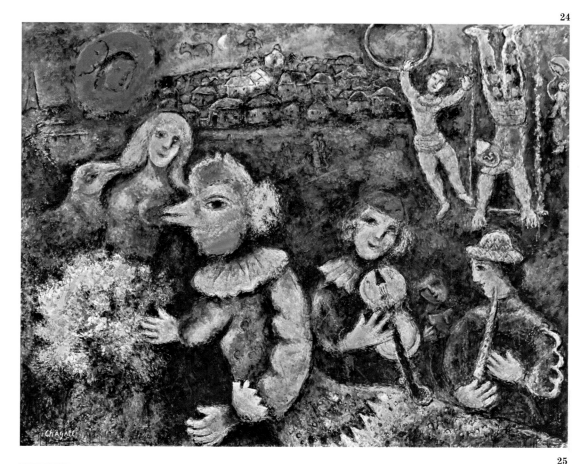

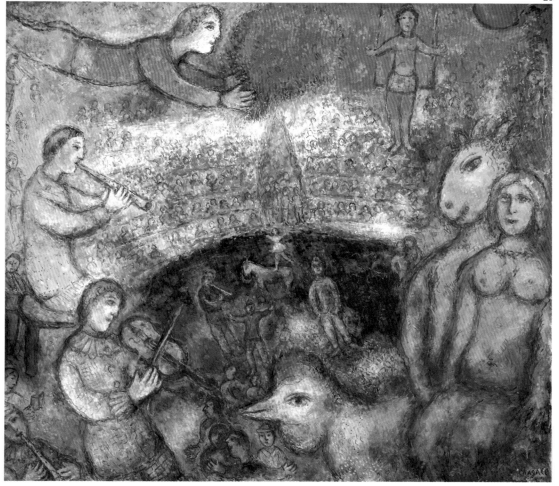

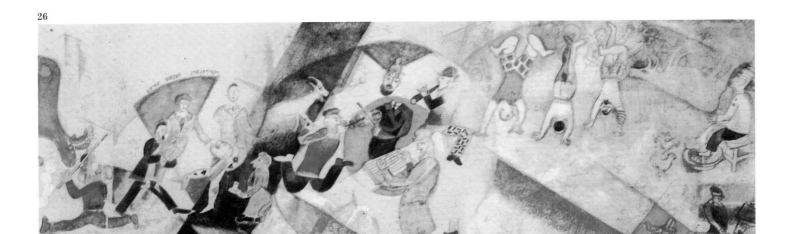

26 *Preparatory sketch for* Introduction to the Jewish Art Theater, *1920. Chagall's collaboration with the Kamerny Jewish Theater resulted in numerous scenographic models and a series of large paintings produced at the request of the theater's director, Alexis Granovski, this one among them.*

27

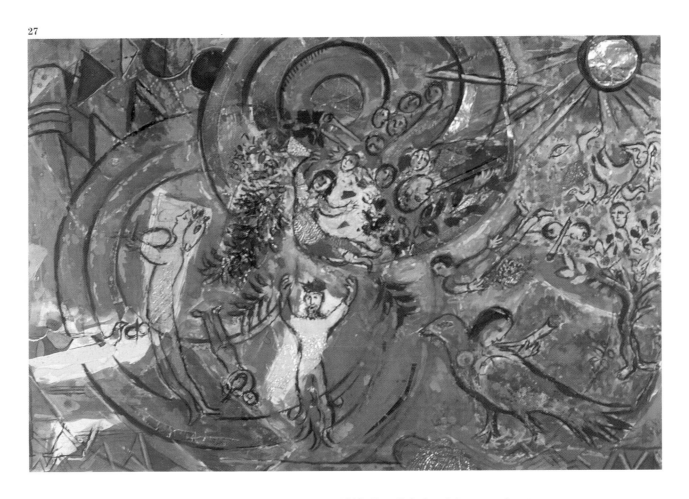

27 *Model for the set of* The Magic Flute, *1967. Chagall designed the sets and costumes for Mozart's work, which was the opening event at the new Metropolitan Opera in New York. For the same opera house he also painted two of his most important murals,* The Sources of Music *and* The Triumph of Music.

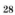
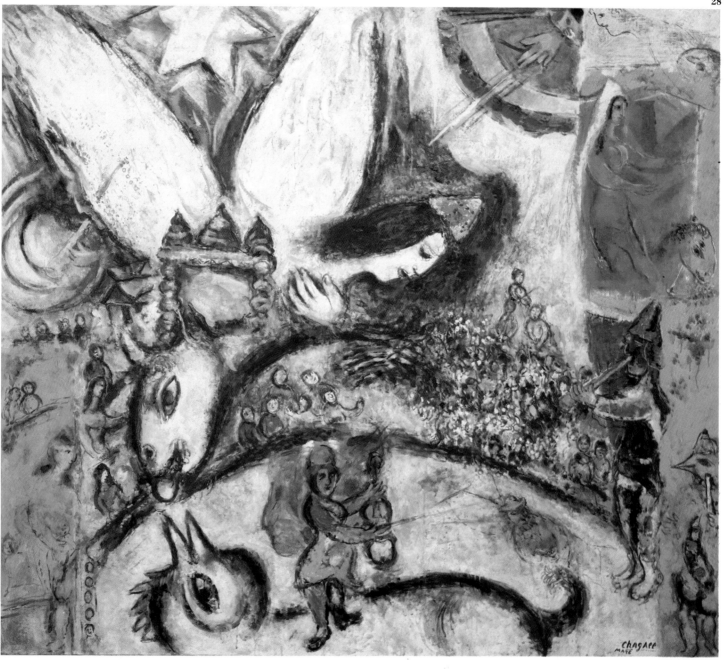

28 The Great Circus, *1968. One of Chagall's most complex works, in which the painter pays homage to artists. In the central ring— a metaphor for the world—an angel appears, impelled by the hand of God, to bless the work of the clown, the equestrienne, the musician, and the painter himself, who, as carriers of the magic of representation, act as intermediaries between the earthly and celestial spheres.*

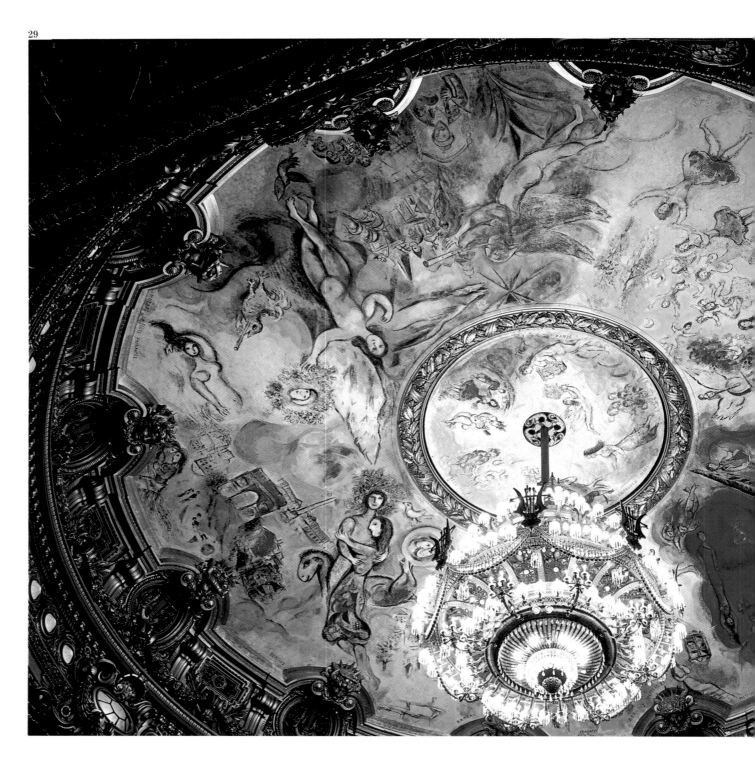

29 The Ceiling of the Paris Opéra, *1964. An exaltation of music,*
love, and the city of Paris, this is probably Chagall's most famous
work. At seventy-seven, Chagall accepted the commission of André
Malraux and President De Gaulle to paint a surface of two
hundred twenty square meters in oil on sizing cloth. To enable
him to handle a work of this size, the French government put the
workshops of the Gobelins Tapestry Manufactory at his disposal.
He also had the considerable help of the master lithographer
Charles Sortier, one of his most faithful collaborators.

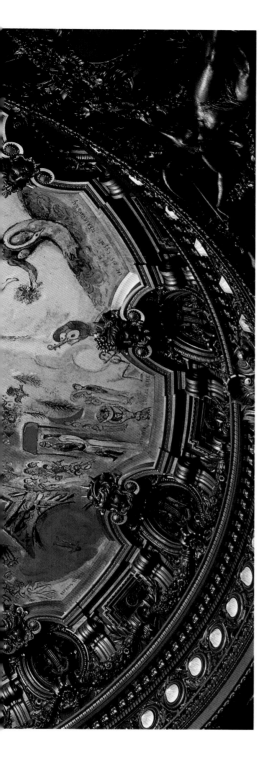

30 Clown with Hoops,
*1966. In some of his
later works, Chagall
applied his colors in
juxtaposed planes,
forming a composition
of colors independent of
the figures in the scene.*

30

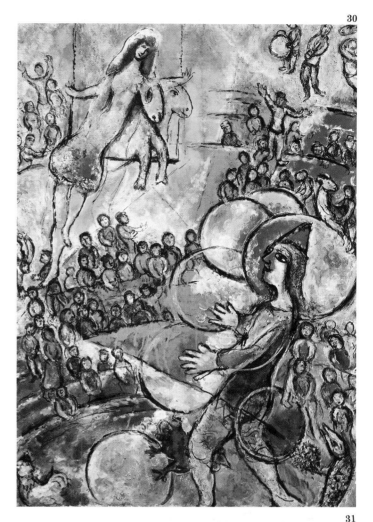

31 Equestrienne on a
Red Horse, *1966. At the
circus, the intrepid
equestriennes are the
female counterparts of
the clowns and jugglers
in the center ring.*

31

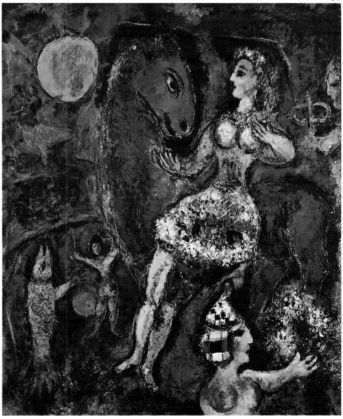

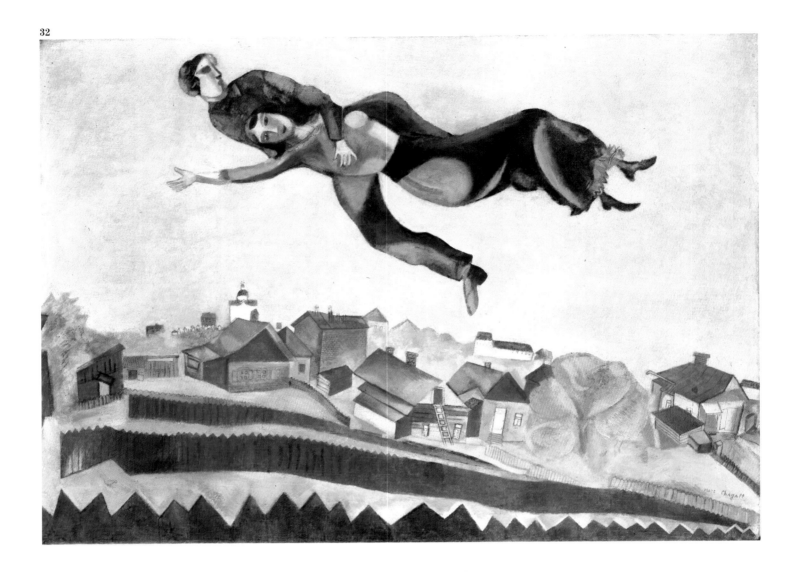

Love

Although not all his works reflect the positive side of human life, for a large part of the contemporary public Chagall is the painter of happiness in love. In his paintings feminine images and embracing couples appear again and again, surrounded by joyful color and exuberant ornament. The landscapes, animals, and plants participate in the radiant happiness of the lovers, encircling them with affection. Many of these paintings are portraits of the two women in his life, Bella Rosenfeld and Valentine Brodsky. In other paintings he depicts himself and his lover in more or less idyllic surroundings. Two motifs are often associated with these loving demonstrations of extravagant lyricism. The first is flight, where love infuses his characters with a freedom that lifts them off the Earth. The second is the bouquet of flowers.

32 Over the City, *1924. To Chagall, love was an expression of freedom. Here the lovers—in this case the painter and his wife, Bella Rosenfeld—throw off their earthly ties and set off on a flight of liberation.*

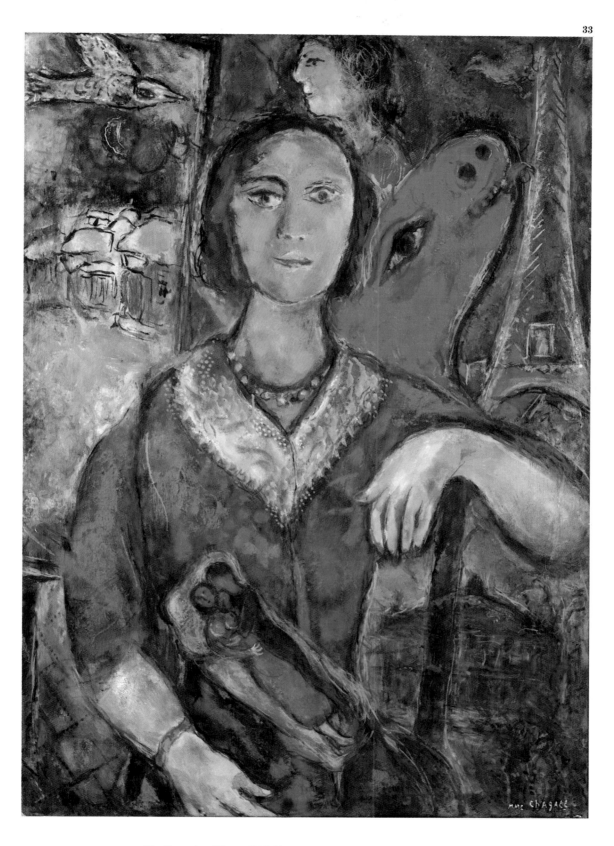

33 Portrait of Vava, *1966. Valentine Brodsky, Chagall's second wife, is shown as the serene defender of the Chagalls' universe. The green color of her face is associated, as in other works by the painter, with the idea of enlightenment. On her abdomen, an embracing couple symbolizes the fertility of love. In the background are the two cities of Vitebsk and Paris.*

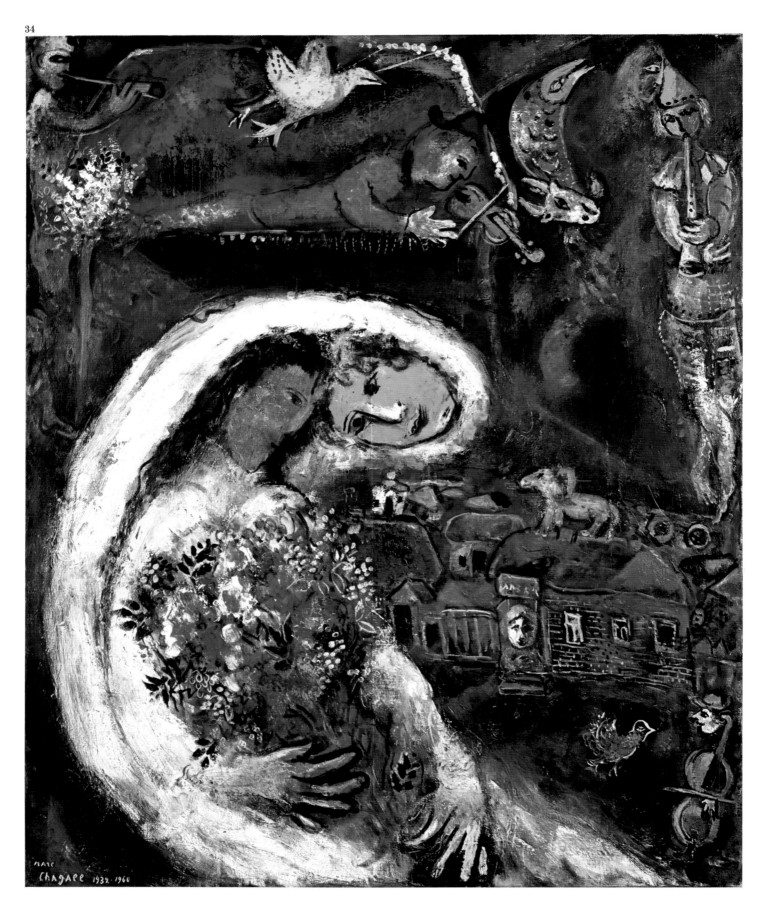

34, 35 Woman with Blue Face, *1932–60*. Winter, *1966. For Chagall, the figure of a
woman represented refuge and light on a winter night. Women are often associated
with music, as in these two later works.*

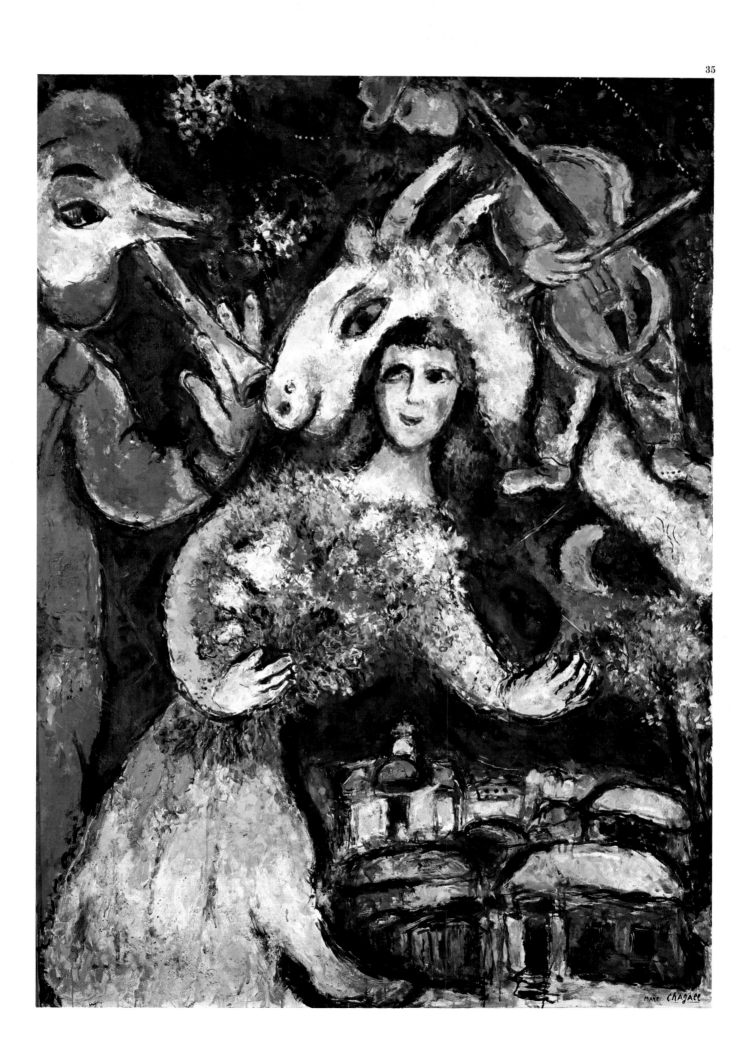

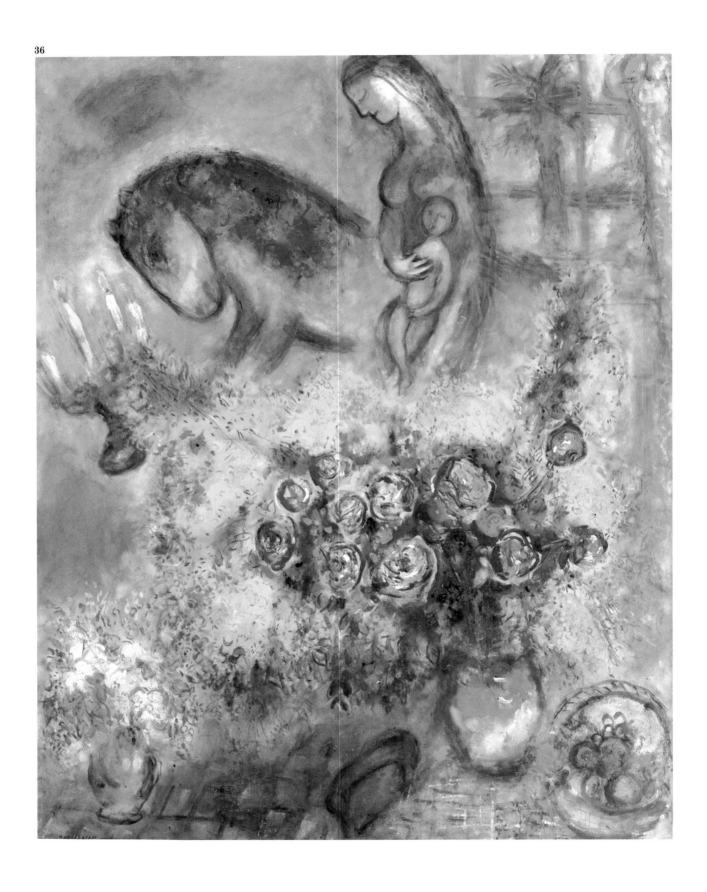

36, 37 Roses and
Mimosas, *1956.*
Gladiolas, *1955–56.*
Flowers appear often in
Chagall's compositions,
always associated with
love, and in these two
images, with maternal
love. Chagall was a great
painter of flowers, on a
par with other modern
masters of this genre,
such as Odilon Redon,
Auguste Renoir, and
Emil Nolde.

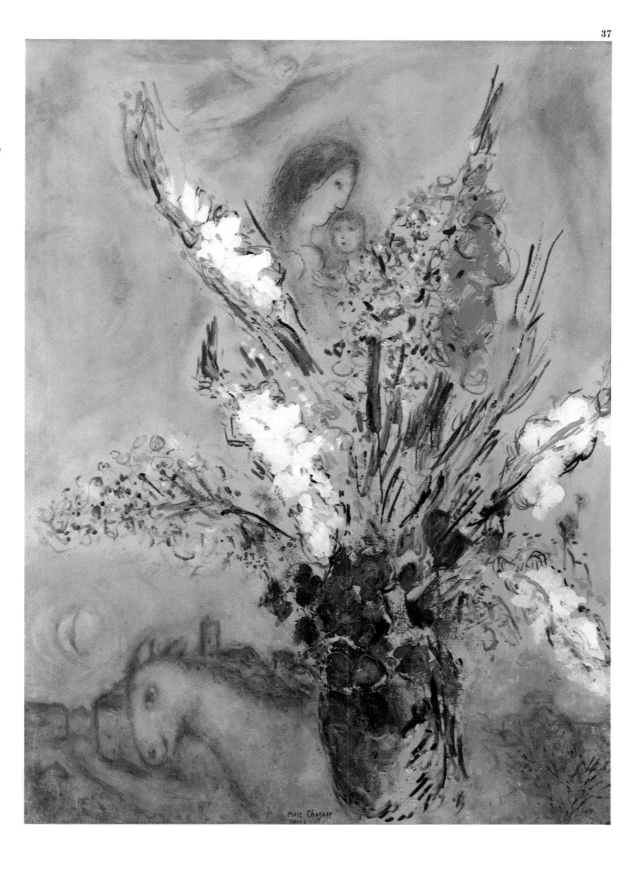

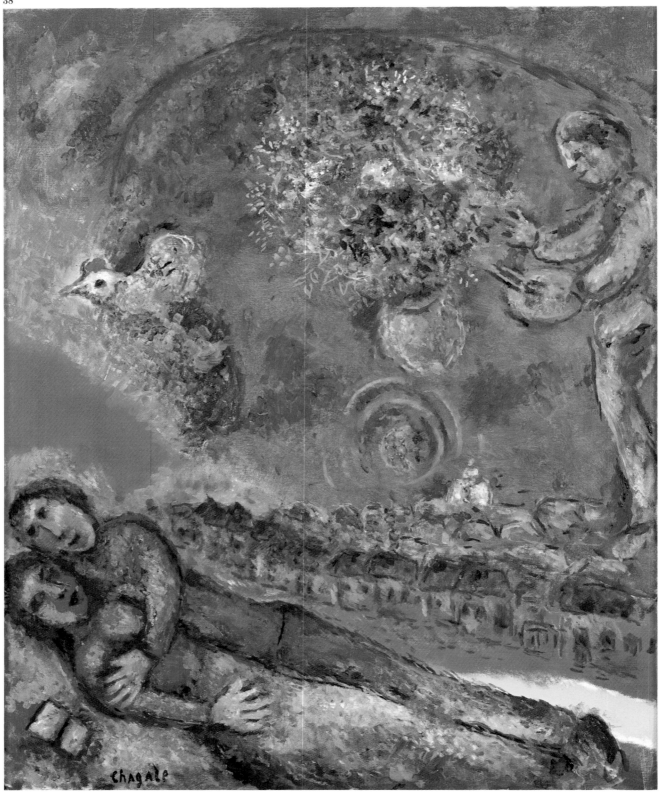

38, 39 Couple on a Red Background, *1983.* The Artist and His Wife,
*1969. Two idyllic images that show the painter and his second
wife, Vava. In many of Chagall's works, the use of color in planes
independent of the motifs is reminiscent of the technique of
another well-known avant-garde artist, Raoul Dufy.*

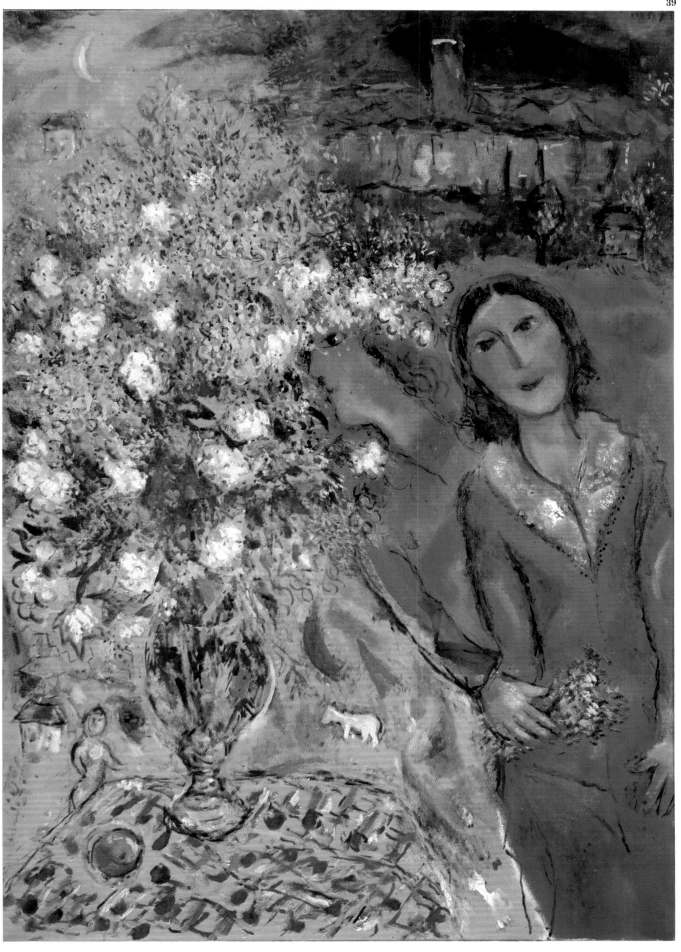

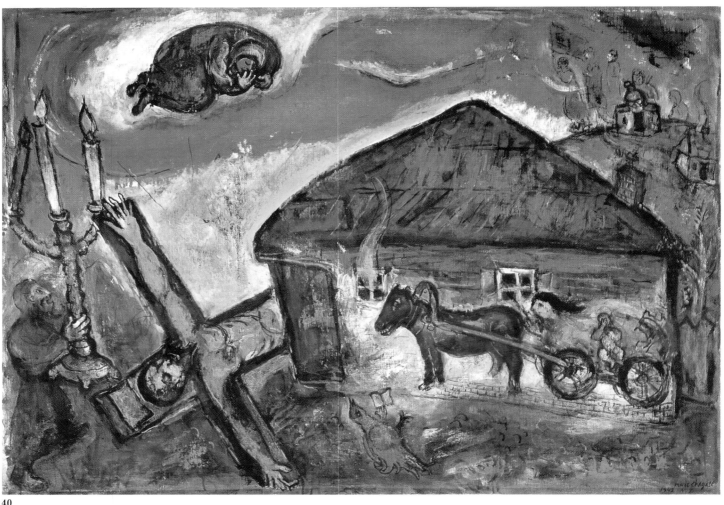

40

"Everything Is Going Black Before My Eyes"

From the middle of the thirties until the end of the forties, Chagall's painting experienced a profound change. In 1933, the same year the first retrospective of his work was held in the Museum of Basel, the Nazis destroyed some of his paintings, attacking him for being a Jew and a "degenerate artist." On June 23, 1941, the day the German offensive against the Soviet Union began, Chagall embarked in Marseilles for the United States. Tragically, his exile was made even more bitter by calamity three years later: the death of his wife Bella in 1944. "Everything is going black before my eyes," the painter wrote only a few days after her death. Following this, the happiness of his previous work gave way to an obsession with tragedy, and his characteristic bright and luminous chromatism was replaced by a mournful range of grays, blacks, and dark blues splattered with screeching motifs in red or yellow and dramatic chiaroscuro effects.

40 Obsession, *1943. Nightmares come to life in the war years. The humble hut is burning and and its inhabitants, covered with blood, flee into the surroundings. The protective symbols—the candelabra, the crucifix—have lost their power.*

41 The Revolution, *1937. Chagall was distrustful of the results of the Revolution. In this image he contrasts his personal world (right) with the clamor of the victors (left). In the center, a pensive rabbi serves as a counterpoint to the acrobatic Lenin, who points the way for his allies to follow. "I think the Revolution could be a great thing if it maintained respect for differences," the artist said.*

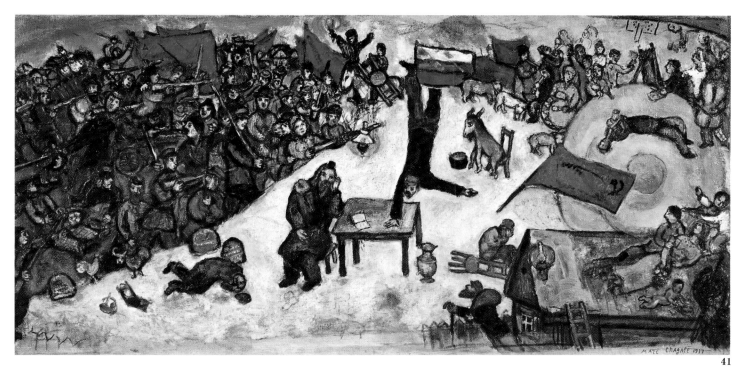

41

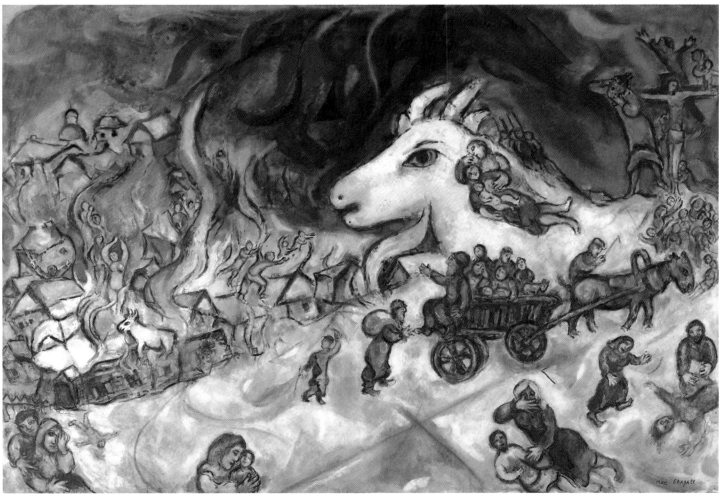

42

42 The War, *1964–66. The horror of war was engraved on Chagall's mind for the rest of his life. His paintings are associated with the two great tragedies of the Jewish people: the Holocaust and the diaspora.*

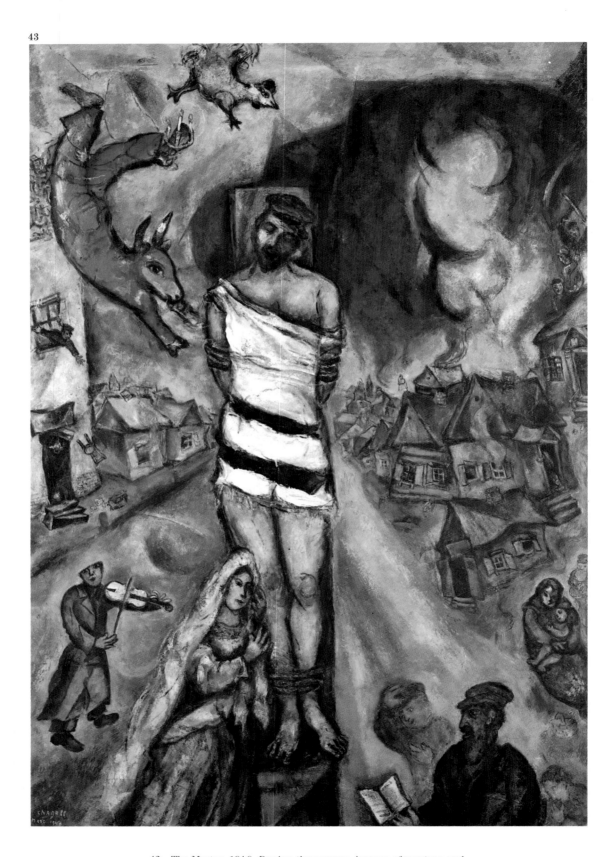

43 The Martyr, *1940. During these years, images of martyrs and scenes of Christ on the cross appeared again and again in Chagall's works. The painter found refuge only in religious faith.*

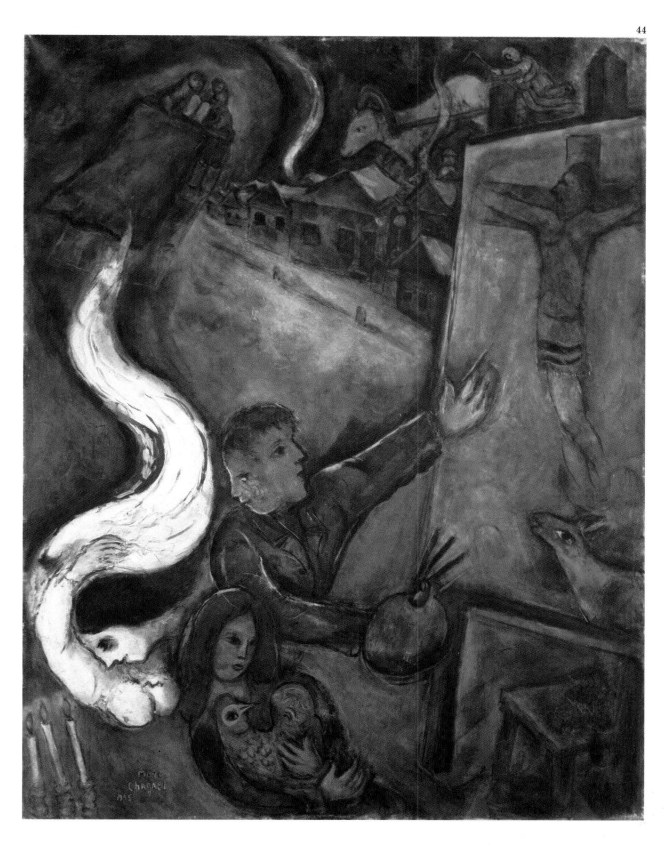

44 The Soul of the City, *1945. To the global tragedy of the War was added the artist's personal tragedy of the death of Bella. In this somber, almost monochromatic painting, his wife comes back to the painter as an apparition, and he expresses his pain by painting an image of the crucifixion.*

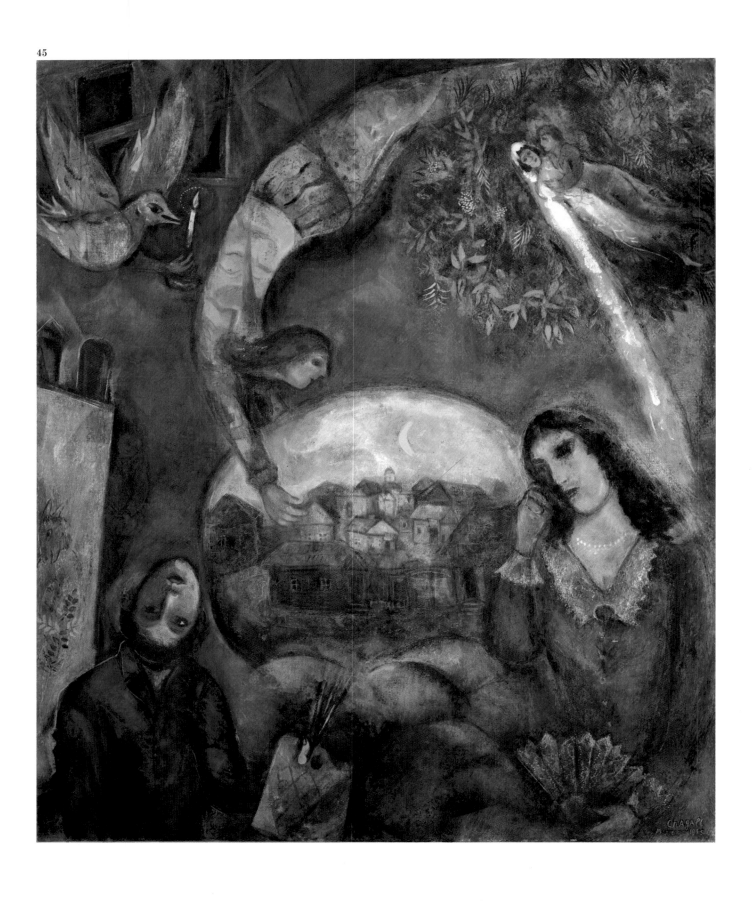

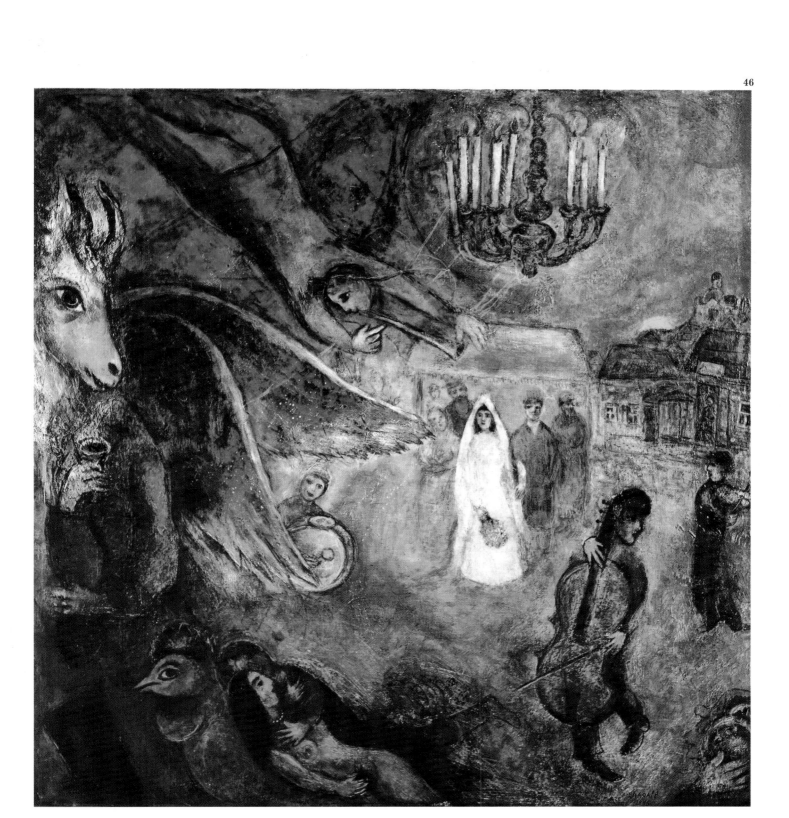

45, 46 About Her, *1945*. The Lights of Marriage, *1945. Chagall*
created these two works by making use of an earlier painting, The
Harlequins, *in which Bella was shown in a happy circus scene.*
Chagall divided that painting in two and, starting with some of
the fragments of the original composition, painted two scenes
marked by the memory of his dead wife. The contrasts of light and
dark in these paintings give both an air of melancholy.

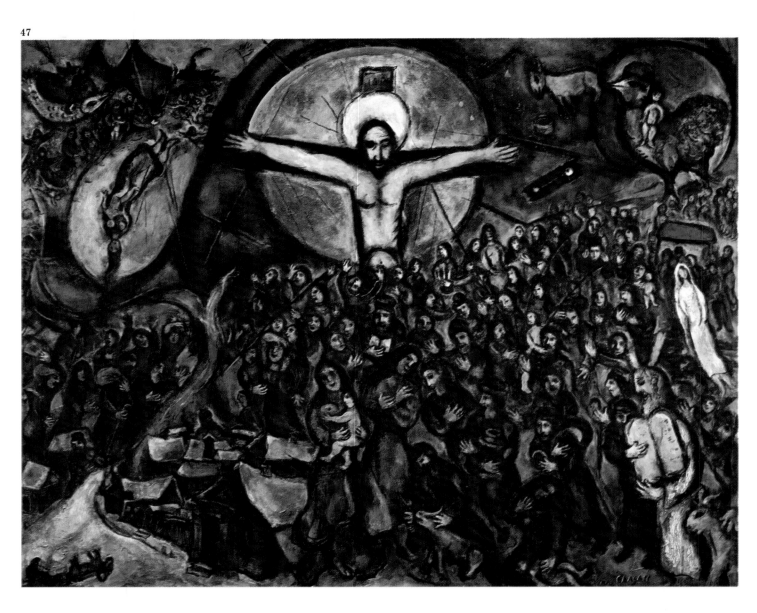

47 Exodus, *1952–56. The luminous yellow figure of the crucified
Christ symbolizes the sacrifice of the Jewish people, wrapped in
darkness. The importance that the image of Christ acquires in
Chagall's iconography reveals the universal scope of his religious
thinking.*

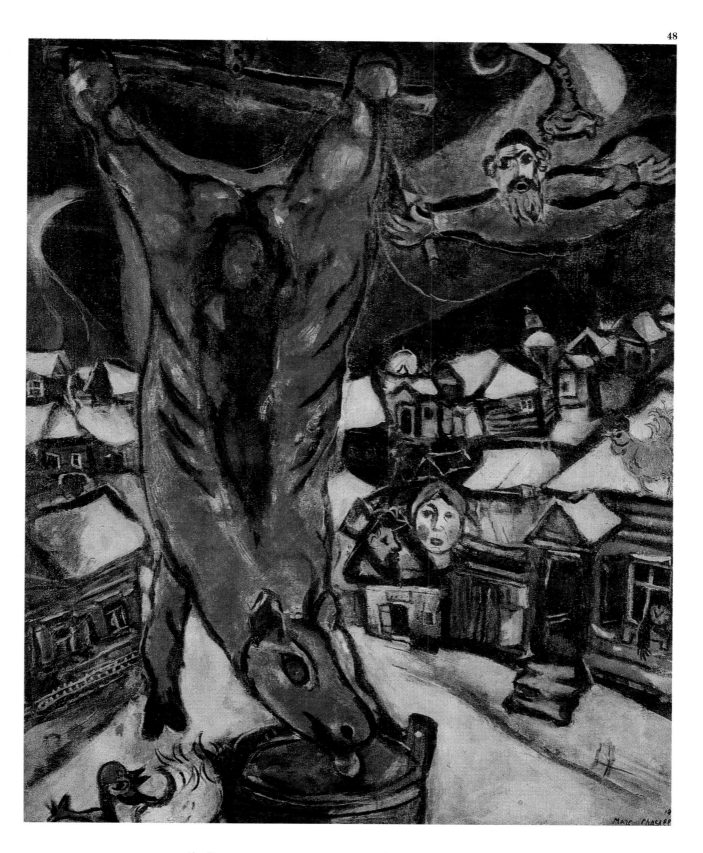

48 The Flayed Ox, *1947. When he was a boy, Chagall often visited his grandfather's slaughterhouse. Later, from his Parisian studio in "La Ruche," he could hear the lowing of the cattle being killed in the nearby slaughterhouse of Vaugirard. As in the well-known images of the same subject by Rembrandt and Soutine, the image of the butchered animal, with its clear religious overtones, is a tragic symbol of human destiny.*

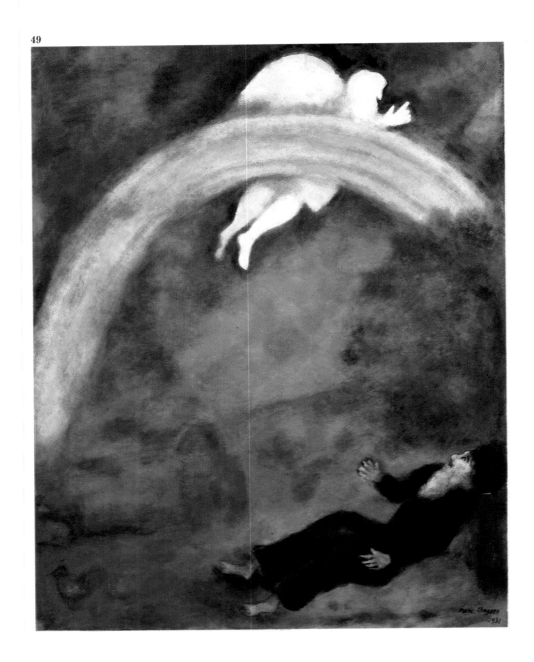

The Biblical Message

"After my early youth, I became captivated by the Bible. It always seemed to me, and it still seems, the greatest source of poetry of all time. Since then I have been looking for that reflection in life and in art. The Bible is like a resonance in nature, and I have tried to transmit that secret." For Chagall, the Bible is the most precious part of a universal cultural legacy, and his use of it is not due to doctrinaire or propagandistic motivations. Just as many of his apparently secular works can be interpreted in a religious sense, many others, which seem explicitly religious, are personal reinterpretations in which images, settings, and personalities from his present, daily life meet primitive characters and spirits. The group of paintings conserved in the Museum of the Marc Chagall Biblical Message in Nice stands out among these works.

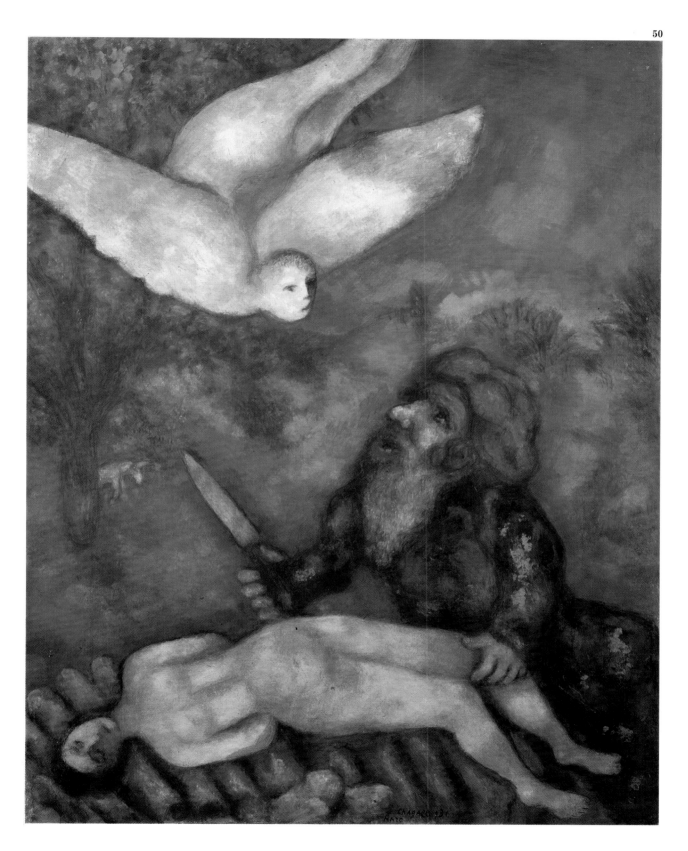

49, 50 The Rainbow, Symbol of the Alliance between God and the
Earth, *1931*. Abraham Preparing to Sacrifice His Son, *1931*. Using
*the medium of gouache, Chagall created a vaporous and dreamlike
setting for the angelic apparitions in these two works.*

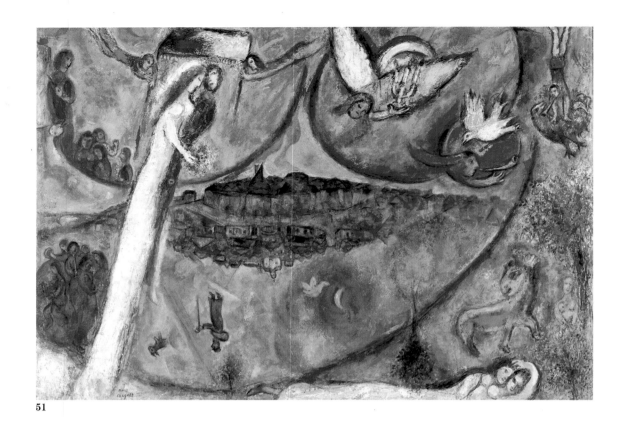

51

51, 52 Song of Songs III, *1960.* Jacob's Dream, *1954–67.*
Belonging to the series of religious paintings preserved in the
Museum of the Marc Chagall Biblical Message in Nice, these two
works, like those on the next page, are excellent examples of
Chagall's chromatic mastery.

52

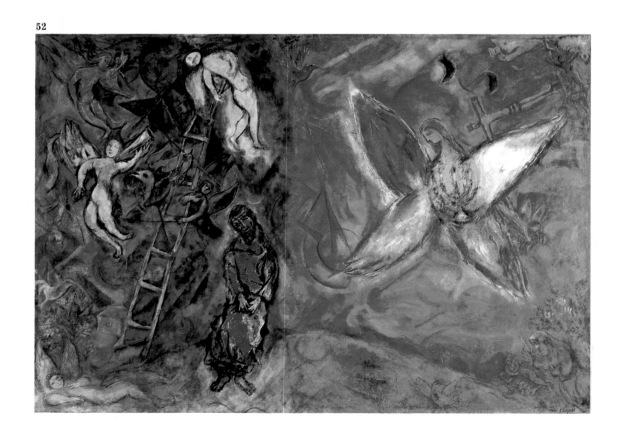

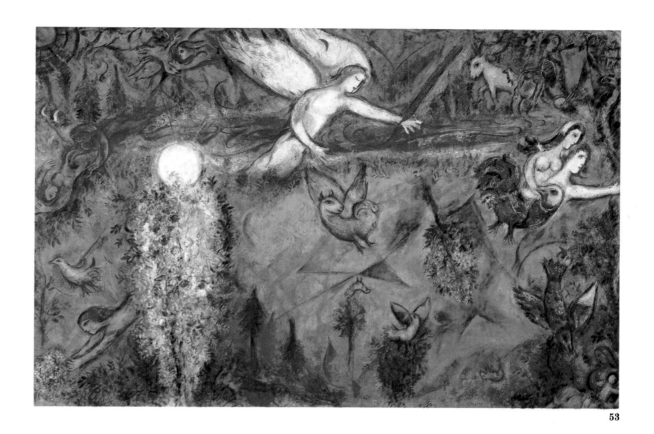

53, 54 Adam and Eve Expelled from Paradise, *1954–67*. Abraham
and the Three Angels, *1954–67. Angels are a recurring motif in
Chagall's work, and, like many of his protagonists, they are
ambiguous, metamorphic beings. As divine messengers, angels
are used to resolve the traditional disassociation of the spiritual
and the material worlds.*

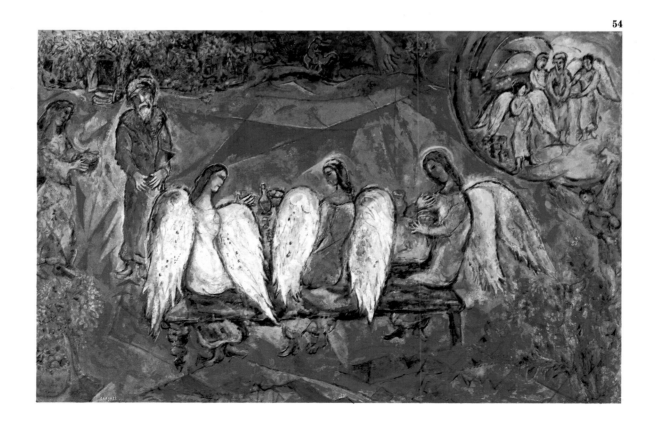

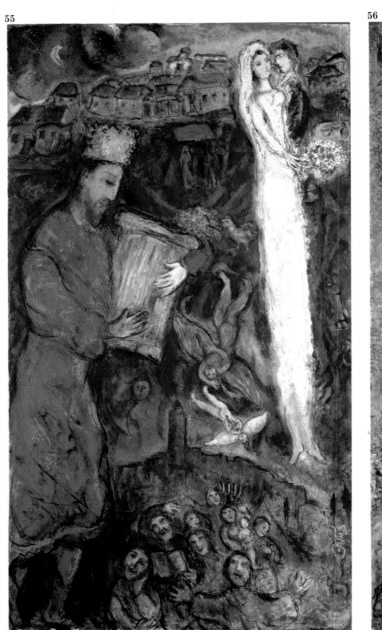
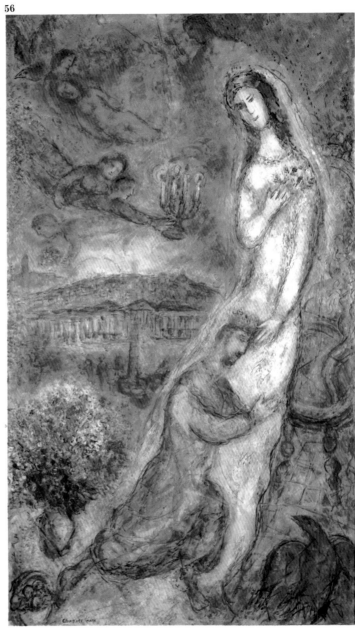

55, 56 David, *1962–63*. Bathsheba, *1962–63. In these two similar
paintings, religious symbols are projected over real settings. The
protagonists of the Biblical story, King David and Bathsheba,
whom he loves, are shown as apparitions in the three principal
cities of Chagall's life. In the painting on the left, Vitebsk is the
background for a wedding party under a red canopy (above),
while a procession moves down the streets of Vence (below). In the
painting on the right, a show of affection takes place in the Place
de la Concorde in Paris.*

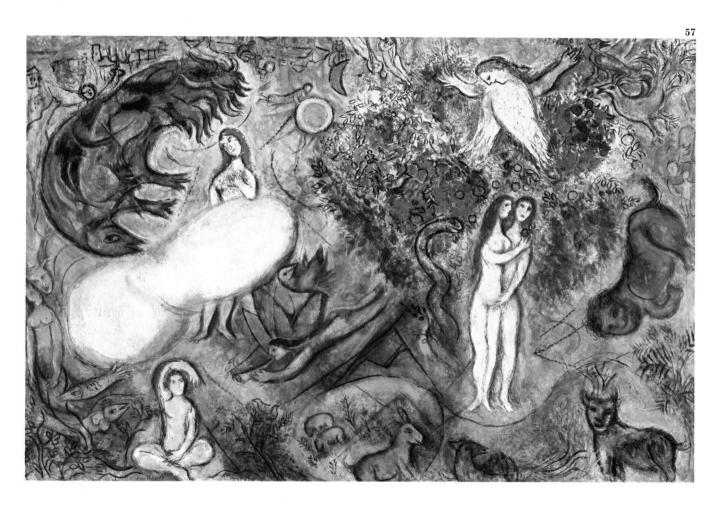

57 Paradise, *1962. Chagall presents Eden as a place of transformation and fluidity, a universe outside time and space. Colors and shapes are distributed harmoniously in a markedly decorative composition.*

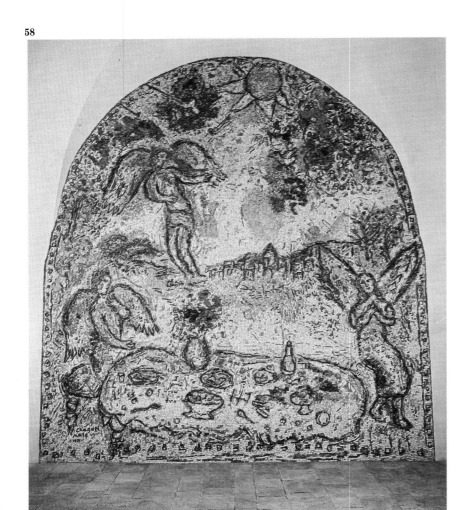

59

Mosaics and Stained-Glass Windows

Given the decorative implications of his mature work, it is not surprising that Chagall would be interested in two media traditionally used in the decoration of interiors: the mosaic and the stained-glass window. His first experiment with this kind of work took place in 1957, when he designed the stained-glass windows for a small mountain church in Plateau d'Assy in Upper Savoy; that same year he started making a series of stained-glass windows for the Cathedral of Metz, an ambitious project with which he was helped by Charles Marq, a master glazier and director of the famed Jacques Simon workshops of Reims. From then on he was to accept many other design commissions, among which were the stained-glass windows of the Cathedral of Reims (1974) and the great wall mosaic of the Museum of the Marc Chagall Biblical Message in Nice.

58, 59, 60 The Offering, *1975.* The Lovers, *1964–65.* The Prophet Elijah, *1970.*
The mosaic image is formed by dots of different colors, which merge in the eye of the viewer. This "pointillist" technique is reminiscent of the one used by the divisionist painters at the end of the nineteenth century. Using this technique, Chagall creates a beautiful effect of chromatic vibration.

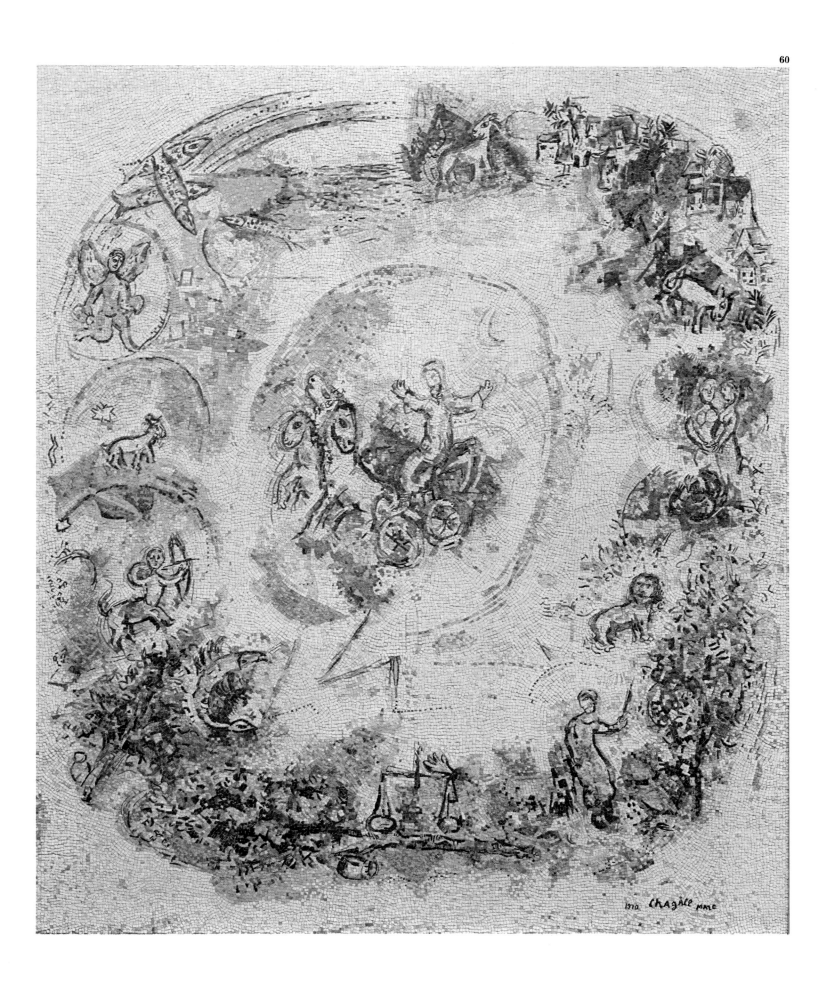

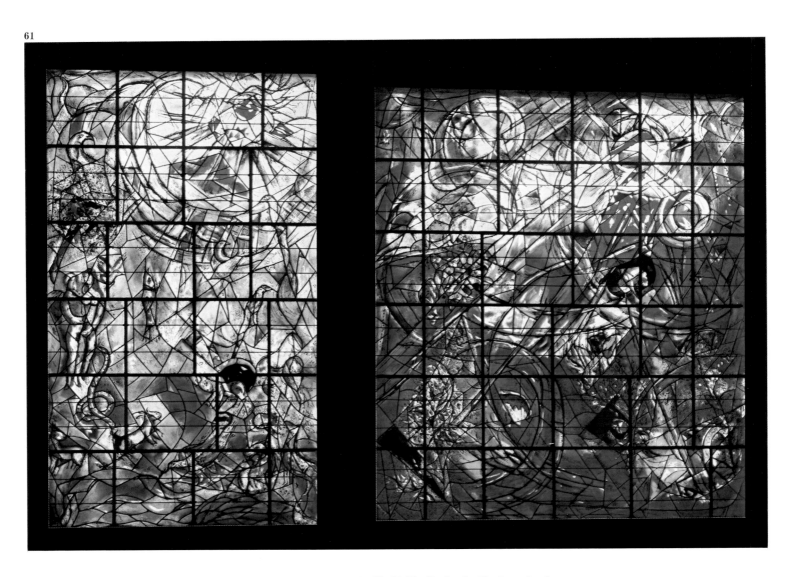

61, 62 The Creation of the World. The Patriarchs Abraham, Jacob, and Moses. 1959–62. *Stained glass offered an unsurpassable medium for Chagall's electrifying colorism. His stained-glass windows are surprisingly consonant with medieval religious buildings, unlike so many modern experiments with this technique.*

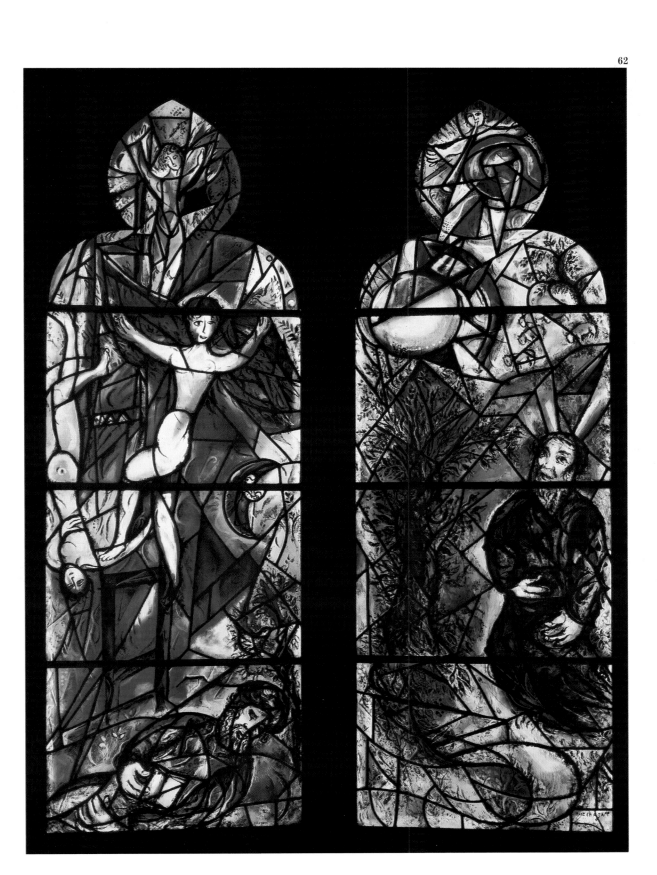

List of Plates

1 Self–Portrait with Seven Fingers. *1912–13. Oil on canvas, 4' 2" × 3' 5" (128 × 107 cm). Stedelijk Museum, Amsterdam.*

2 The Violinist. *1911. Oil on canvas, 3' 1" × 2' 3" (94.5 × 69.5 cm). Kunstsammlung Nordrhein-Westfalen, Düsseldorf.*

3 Homage to Apollinaire. *1911–12. Oil on canvas, 6' 9" × 6' 5" (209 × 198 cm). Van Abbemuseum, Eindhoven.*

4 The Poet (Half-Past Three). *1911. Oil on canvas, 6' 4" × 4' 8" (196 × 145 cm). Philadelphia Museum of Art. The Louise and Walter Arensburg Collection.*

5 To Russia, Asses, and Others. *1911–12. Oil on canvas, 5' 1" × 4' (156 × 122 cm). Musée National d'Art Moderne, Centre Georges Pompidou, Paris.*

6 The Soldier Drinks. *1912. Oil on canvas, 3' 6" × 3' 1" (110 × 95 cm). The Solomon R. Guggenheim Museum, New York.*

7 The Apparition. *1917. Oil on canvas, 5' 2" × 4' 6" (157 × 140 cm). Russian Culture Ministry, Saint Petersburg.*

8 Cubist Landscape. *1918. Oil on canvas, 3' 3" × 1' 9" (100 × 59 cm). Private collection, Paris.*

9 Over Vitebsk. *1914. Oil on reinforced cardboard, 2' 4" × 3' (73 × 92.5 cm). Art Gallery of Ontario, Toronto. Donation by Sam and Ayala Zacks.*

10 Feast Day (Rabbi with Lemon). *1914. Oil on cardboard, 3' 3" × 2' 6" (100 × 80.5 cm). Kunstsammlung Nordrhein-Westfalen, Düsseldorf.*

11 The Newspaper Seller. *1914. Oil on canvas, 3' 2" × 2' 6" (98 × 78.5 cm). Private collection, Paris.*

12 Bella with a White Collar. *1917. Oil on canvas, 4' 9" × 2' 4" (149 × 72 cm). Artist's collection.*

13 The Violinist in Green. *1918. Oil on canvas, 6' 4" × 3' 5" (195.6 × 108 cm). The Solomon R. Guggenheim Museum, New York. Donation by Solomon R. Guggenheim.*

14 The Rooster. *1929. Oil on canvas, 2' 7" × 2' 1" (81 × 65 cm). Museo Thyssen, Madrid.*

15 The Fantastic City. *1968–71. Oil on canvas, 3' × 2' 1" (92 × 65 cm). Artist's collection.*

16 Peasant Life. *1925. Oil on canvas, 3' 3" × 2' 7" (100 × 81 cm). Albright-Knox Art Gallery, Buffalo.*

17 The Juggler. *1943. Oil on canvas, 3' 6" × 2' 6" (109 × 79 cm). The Art Institute, Chicago. Donation by Mme. Gilbert Chapman.*

18 Birds in the Night. *1967. Oil on canvas, 2' 7" × 3' 8" (81 × 116 cm). Private collection.*

19 The Fall of Icarus. *1975. Oil on canvas, 6' 10" × 6' 5" (213 × 198 cm). Musée National d'Art Moderne, Centre Georges Pompidou, Paris.*

20 The Sun-Bird. *1969. Oil on canvas, 3' 8" × 2' 9" (116 × 89 cm). Private collection.*

21 Circus Scene. *1968–71. Lithograph, 11" × 9" (28 × 23 cm). Private collection.*

22 Entering the Ring. *1968–71. Oil on canvas, 3' × 2' 4" (92 × 73 cm). Private collection, Milan.*

23 Clown Lying Down. *1968–71. Oil on canvas, 2' 4" × 3' (73 × 92 cm). Private collection, Milan.*

24 Carnival at Night. *1979. Oil on canvas, 4' 3" × 5' 3" (130 × 160 cm). Pierre Matisse Gallery, New York.*

25 The Great Parade. *1979–80. Oil on canvas, 3' 9" × 4' 3" (119 × 132 cm). Pierre Matisse Gallery, New York.*

26 Sketch for "Introduction to the Jewish Art Theater." *1920. Pencil and gouache on ochre paper, 6" × 1' 6" (17.5 × 48 cm). Artist's collection.*

27 Model for the set of "The Magic Flute." *1967. Pencil, gouache, India ink and collage of printed paper, 1' 8" × 2' 4" (55 × 74 cm). Artist's collection.*

28 The Great Circus. *1968. Oil on canvas, 5' 6" × 5' 2" (170 × 160 cm). Pierre Matisse Gallery, New York.*

29 The Ceiling of the Paris Opéra. *1964. Oil on sizing cloth, 722' × 722' (220 × 220 m).*

30 Clown with Hoops. *1966. Oil on canvas, 3' × 2' 1" (92 × 65 cm). Private collection.*

31 Equestrienne on a Red Horse. *1966. Oil on canvas, 4' 9" × 3' 9" (150 × 120 cm). Artist's collection.*

32 Over the City. *1924. Oil on canvas, 2' 2" × 2' 10" (67.5 × 91 cm). Galerie Beyeler, Basel.*

33 Portrait of Vava. *1966. Oil on canvas, 3' × 2' 1" (92 × 65 cm). Artist's collection.*

34 Woman with Blue Face. *1932–60. Oil on canvas, 3' 3" × 2' 7" (100 × 82 cm). Private collection.*

35 Winter. *1966. Oil on canvas, 5' 3" × 3' 7" (162 × 114 cm). Artist's collection.*

36 Roses and Mimosas. *1956. Oil on canvas, 4' 6" × 3' 7" (145 × 113 cm). Evelyn Sharp Collection.*

37 Gladiolas. *1955–56. Oil on canvas, 4' 3" × 3' 2" (130 × 97 cm). Gustav Zumsteg Collection, Zurich.*

38 Couple on a Red Background. *1983. Oil on canvas, 2' 7" × 2' 1" (81 × 65.5 cm). Artist's collection.*

39 The Artist and His Wife. *1969. Oil on canvas, 3' × 2' 4" (92 × 73 cm). Artist's collection.*

40 Obsession. *1943. Oil on canvas, 2' 5" × 3' 5" (77 × 108 cm). Private collection.*

41 The Revolution. *1937. Oil on canvas, 1' 6" × 3' 3" (50 × 100 cm). Artist's collection.*

42 The War. *1964–66. Oil on canvas, 5'3" × 7'6" (163 × 231 cm). Kunsthaus, Zurich. Vereinigung Zürcher Kunstfreunde.*

43 The Martyr. *1940. Oil on canvas, 5'4" × 3'7" (164.5 × 114 cm). Kunsthaus, Zurich. Donation by Electrowatt AG, Zurich.*

44 The Soul of the City. *1945. Oil on canvas, 3'5" × 2'7" (107 × 81.5 cm). Musée National d'Art Moderne, Centre Georges Pompidou, Paris.*

45 About Her. *1945. Oil on canvas, 4'3" × 3'6" (131 × 110 cm). Musée National d'Art Moderne, Centre Georges Pompidou, Paris.*

46 The Lights of Marriage. *1945. Oil on canvas, 4' × 3'9" (123 × 120 cm). Private collection.*

47 Exodus. *1952–66. Oil on canvas, 4'3" × 5'3" (130 × 162 cm). Artist's collection.*

48 The Flayed Ox. *1947. Oil on canvas, 3'3" × 2'7" (101 × 81 cm). Private collection, Paris.*

49 The Rainbow, Symbol of the Alliance between God and the Earth. *1931. Gouache on paper, 2' × 1'6" (63.5 × 47.5 cm). Musée National Message Biblique Marc Chagall, Nice.*

50 Abraham Preparing to Sacrifice His Son. *1931. Oil and gouache on paper, 2'1" × 1'7" (65.5 × 52 cm). Musée National Message Biblique Marc Chagall, Nice.*

51 The Song of Songs III. *1960. Oil on canvas, 4'9" × 7'5" (149 × 230 cm). Musée National Message Biblique Marc Chagall, Nice.*

52 Jacob's Dream. *1954–67. Oil on canvas, 6'4" × 9'1" (195 × 278 cm). Musée National Message Biblique Marc Chagall, Nice.*

53 Adam and Eve Expelled from Paradise. *1954–67. Oil on canvas, 6'2" × 9'3" (190 × 284 cm). Musée National Message Biblique Marc Chagall, Nice.*

54 Abraham and the Three Angels. *1954–67. Oil on canvas, 6'2" × 9'6" (190 × 292 cm). Musée National Message Biblique Marc Chagall, Nice.*

55 David. *1962–63. Oil on canvas, 5'9" × 3'2" (180 × 98 cm). Private collection.*

56 Bathsheba. *1962–63. Oil on canvas, 5'9" × 3'1" (180 × 96 cm). Private collection.*

57 Paradise. *1962. Oil on canvas, 6'5" × 9'4" (199 × 288 cm). Musée National Message Biblique Marc Chagall, Nice.*

58 The Offering. *1975. Mosaic, 21'8" × 18'7" (665 × 570 cm). Chapel of Sainte-Rosaline, Les Arcs.*

59 The Lovers. *1964–65. Mosaic, 9'8" × 9'4" (300 × 285 cm). Fondation Maeght, Saint-Paul-de-Vence.*

60 The Propher Elijah. *1970. Mosaic, 23'5" × 18'7" (715 × 570 cm). Musée National Message Biblique Marc Chagall, Nice.*

61 The Creation of the World. *Stained-glass window: left, "The Fifth and Sixth Days"; right, "The First Four Days." Musée National Message Biblique Marc Chagall, Nice.*

62 The Patriarchs Abraham, Jacob, and Moses. *1959–62. Stained-glass window (part): left, "Jacob's Dream"; right, "Moses before the Burning Bush." Saint-Étienne Cathedral, Metz.*

Series Coordinator, English-language edition: Ellen Rosefsky Cohen
Editor, English-language edition: Elaine M. Stainton
Designer, English-language edition: Judith Michael

ISBN 0–8109–4677–7

Printed and bound in Spain by La Polígrafa, S.L.
Parets del Vallès (Barcelona)
Dep. Leg.: B. 22.010-1995